Nancy Wagner

THE POSTCARD HISTORY SERIES

Birmingham
A POSTCARD TOUR

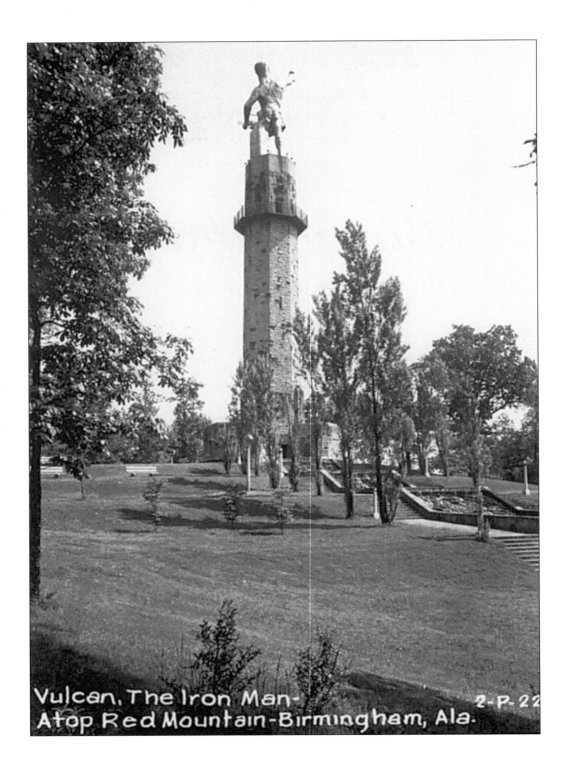

Vulcan, The Iron Man-
Atop Red Mountain-Birmingham, Ala.

2-P-22

THE POSTCARD HISTORY SERIES

Birmingham
A POSTCARD TOUR

J.D. Weeks

ARCADIA

Published by Arcadia Publishing,
an imprint of Tempus Publishing, Inc.
2 Cumberland Street
Charleston, SC 29401

Printed in Great Britain.

Library of Congress Catalog Card Number:

For all general information contact Arcadia Publishing at:
Telephone 843-853-2070
Fax 843-853-0044
E-Mail arcadia@charleston.net

For customer service and orders:
Toll-Free 1-888-313-BOOK

Visit us on the internet at http://www.arcadiaimages.com

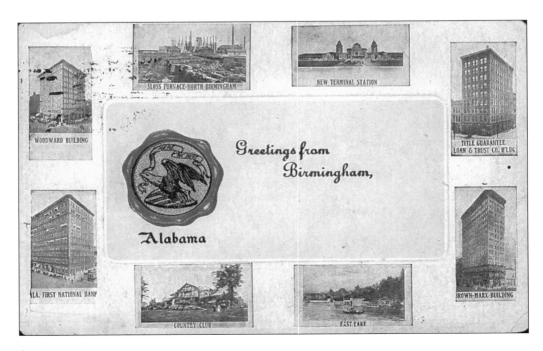

CONTENTS

Acknowledgments 6

Introduction 7

1. Downtown Views and Buildings 9

2. Neighborhoods and Surrounding Communities 33

3. Steel, Coal and Iron Ore Mining, and Other Industries 47

4. Schools and Public Buildings 65

5. Hospitals and Churches 83

6. Hotels 99

7. Parks 109

8. Miscellaneous 121

Bibliography 127

ACKNOWLEDGMENTS

I am extremely fortunate to live near the Birmingham Public Library and have the opportunity to use their facilities, especially the Linn-Henley Research Library located in the old building. My personal library contains many books and publications made available to their patrons over the years. I am indebted to George Stewart, former director of the Birmingham Public Library, for sparking my interest in the early history and development of Birmingham through a course he taught at the University of Alabama in Birmingham (UAB) over 20 years ago. The books and publications produced by the Jefferson County Historical Commission and the Birmingham Historical Society have been valuable tools as well.

I also want to thank my grandchildren; Jarred Brittian, Christopher Shelnutt, Matthew Shelnutt, James Brittian, Edmund Weeks, and Hugh Weeks; who helped me select the postcards. The little ones, Elizabeth Shelnutt and Jonathan Shelnutt, also did a remarkable job and responded to the frequent "No, No" appropriately, only occasionally seizing a postcard that, to them, must have appeared abandoned.

This book is dedicated to the loving memory of my grandson, Stephen Middleton Weeks.

INTRODUCTION

As we reflect on the closing of the 20th century and begin the next millennium, we appreciate the fact that it was photographed and preserved on view postcards. Traveling photographers, scouring the country, captured images of cities, large and small. These wonderful photographs were printed on postcards, mostly in Germany and England due to superior printing technology. Local postcard publishers like William H. Faulkner, who operated the Birmingham Postcard Exchange in Birmingham from 1909 until 1917, also produced local images. Many of the postcards in this book were published, and sold along with other postcards, by the Birmingham Postcard Exchange. After 1917, when the Postcard Exchange closed, Faulkner continued to produce postcards under the name of Faulkner's Novelty Company. This book is the result of my combined passion for local history and collecting postcards, especially postcards depicting local views of a time when Birmingham was a leading industrial center and one of the largest and fastest growing cities in the South.

Native Americans inhabited this part of Alabama until Andrew Jackson defeated the Creek Nation at the Battle of Horseshoe Bend, near Dadeville, Alabama, in 1814. The subsequent Treaty of Fort Jackson ceded land to the United States, some of which now makes up about half of the present state of Alabama, including the Birmingham area. This opened up the land for settlement, and pioneers began to appear almost immediately, many of them soldiers who had fought with Jackson. This area was rich in coal, iron ore, and limestone. It was the only place on the globe where all three ingredients necessary for producing steel were plentiful in one location. The early farmers and settlers largely ignored these valuable resources.

The town of Elyton incorporated in 1820 at the intersection where three pony express and stage lines crossed. These were the Montevallo Road, Huntsville Road, and Georgia Road. The Alabama and Chattanooga Railroad, which was to run from Chattanooga to Tuscaloosa, had been started before the Civil War and had almost reached the area. Another railroad, the South and North, was being constructed to run from Montgomery to Decatur. A group of capitalists, promoters, and opportunists formed the Elyton Land Company and purchased 4,150 acres of land east of Elyton. They persuaded the two railroads to intersect in the center of their newly purchased property where they planned to build a city, which would become Birmingham.

Birmingham was incorporated in 1871, and its rapid industrial growth in the 1870s earned it the name "the Magic City." An aggressive annexation program in 1910 brought in the towns of South Highland, North Birmingham, Ensley, Woodlawn, East Lake, North Highlands, and others. By that time, the population of Birmingham had grown from 800 in 1871 to 132,685.

Now, back to the postcards. Austria has the distinction of introducing the first government-issued postal card in 1869. Other European countries followed shortly, and the United States produced their first postal card in 1873. The government-produced postal cards were mailed with a 1¢ stamp while letters and privately produced postcards required a 2¢ stamp. This disparity was corrected when the United States passed the Private Mailing Card Act of 1898 allowing both the postal card and privately produced postcard to use the 1¢ stamp. Thus began the large-scale production of privately produced postcards, just in time to capture the budding new city of Birmingham.

Fortunately, the Birmingham area was developing during the "golden age of postcards," which was from around 1900 to the start of World War I. United States postal records indicate that 677,777,798 postcards were mailed in 1907, when the population of the United States was only 88,700,000. This number does not include the huge quantities of postcards placed in albums or saved and never mailed.

Not many folks alive today can recall this time, and most of us only read about it. Through the magic of postcards, this exciting period was captured for us with scenes from everyday life including workplaces, residences, downtown buildings, neighborhoods, schools, churches, hotels, hospitals, industrial sites, public buildings, parks, and more. This book features these scenes through almost 200 carefully selected antique view postcards from my personal collection of around 3,000 early Birmingham area postcards. It is not intended to be an historical text, only an outlet for an avid postcard collector who loves local history. The bibliography provides excellent sources for detailed historical information about early Birmingham. I resisted the temptation to interject personal memories I have of many of the views and tried very hard to maintain objectivity. I sincerely hope you enjoy your postcard tour of Birmingham at the start of the 20th century.

One

DOWNTOWN VIEWS
AND BUILDINGS

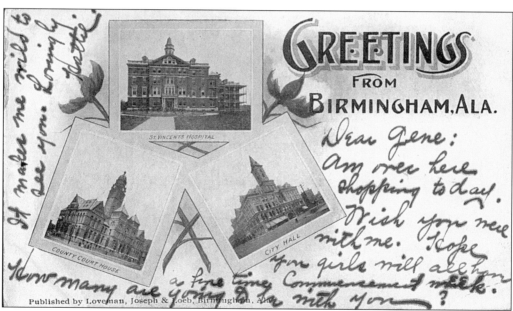

GREETINGS FROM BIRMINGHAM, ALA. This postcard, mailed in 1906, is typical of the "greetings" type popular at the turn of the 20th century. It contains three views of prominent buildings of the time—St. Vincent's Hospital, County Courthouse, and City Hall. Until March 1, 1907, the message could only be written on the front of the postcard, as this one was. Loveman, Joseph & Loeb, an early department store established in Birmingham in 1899, published this postcard.

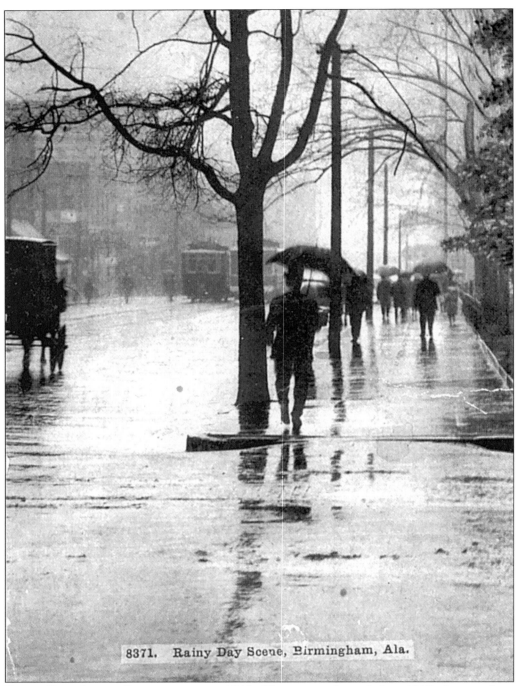

8371. Rainy Day Scene, Birmingham, Ala.

RAINY DAY SCENE, BIRMINGHAM, C. 1910. This postcard, mailed in 1910, shows a busy downtown street scene much like you would see today on a rainy afternoon, except for the horse and buggy and streetcars, of course. This scene must have "moved" the photographer since no landmarks are readily distinguishable. Now, after almost a century, this rainy day scene of an unidentified intersection still captivates the viewer.

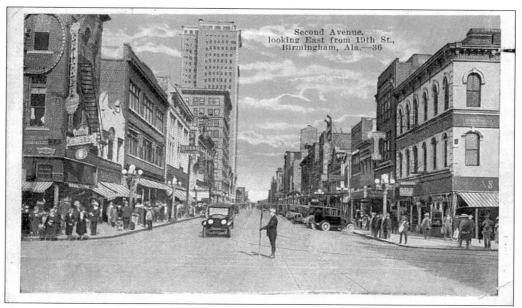

SECOND AVENUE, LOOKING EAST FROM NINETEENTH STREET, C. 1936. This postcard view shows how Second Avenue looked in the 1930s. On the left corner is Jaffee Jewelry Co., then Silver's 5&10, S.H. Kress, Jobe Rose Jewelry, and F.W. Woolworth. On the right are Schulte Cigar, Strand Theatre, and Capitol Theatre.

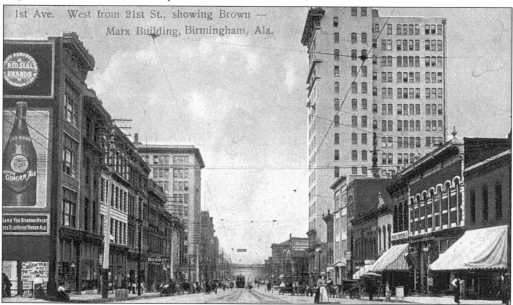

FIRST AVENUE WEST FROM TWENTY-FIRST STREET, SHOWING BROWN-MARX BUILDING, C. 1908. This view of First Avenue, looking west from Twenty-first Street, shows the Brown-Marx Building at the end of the street on the right. Signs can be seen for R.D. Burnette Cigar Co., Seales Piano Company, Broyles Furniture, Wimberly & Thomas Hardware, and Zac Smith Stationary, all early businesses established in Birmingham. A sign on the side of the building to the left advertises pure California wines for $1 a gallon and 30¢ a quart.

11

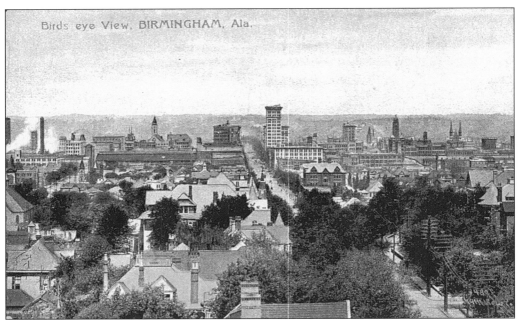

BIRD'S EYE VIEW, BIRMINGHAM. This is a rooftop view looking north from Southside down Twentieth Street. It is sometime before 1912 because the American Trust & Savings Bank Building has not been built. Paul Hayne School can be seen on the right, and you can see that this part of Birmingham is still mostly residences.

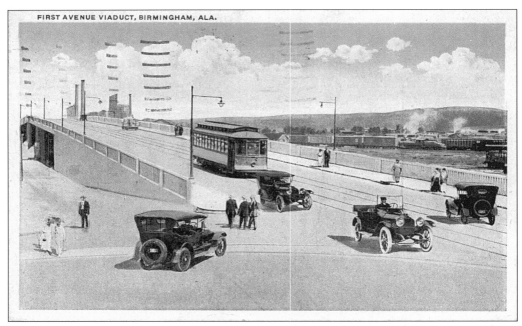

FIRST AVENUE VIADUCT, BIRMINGHAM, C. 1920. The First Avenue viaduct ran over and past Sloss Furnace, seen in the background. This postcard, mailed in 1920, shows the intersection of First Avenue and Twenty-sixth Street North.

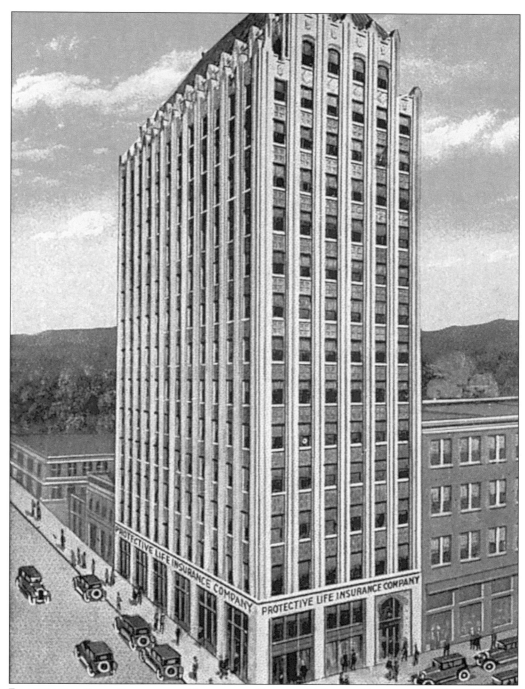

PROTECTIVE LIFE INSURANCE BUILDING. Former Alabama Governor William D. Jelks organized the Protective Life Insurance Company in Birmingham in 1907. He later purchased the Ledger Building, a three-story structure built in 1911, and added eleven more floors in 1928. Protective Life remained there until 1976, when they moved to a 28-acre wooded site in Mountain Brook.

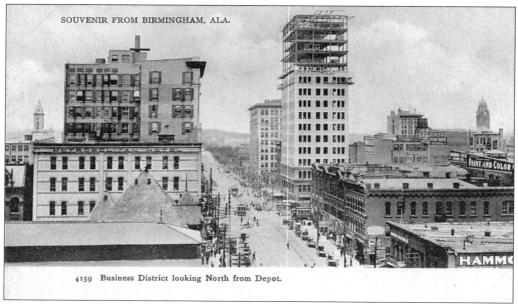

SOUVENIR FROM BIRMINGHAM, ALA.

4159 Business District looking North from Depot.

BUSINESS DISTRICT, LOOKING NORTH FROM DEPOT. This view from the roof of the Depot, looking north down Twentieth Street, shows the Metropolitan Hotel on the left and the Woodward Building on the corner of First Avenue and Twentieth Street. The Brown-Marx Building, on the right, is under construction and dates this postcard at about 1906 or maybe 1905.

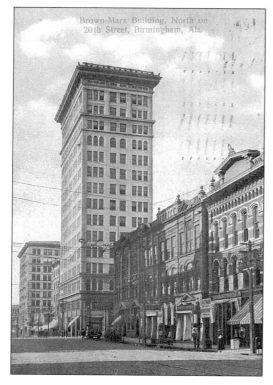

Brown-Marx Building, North on 20th Street, Birmingham, Ala.

BROWN-MARX BUILDING, NORTH ON TWENTIETH STREET, C. 1907. This view shows the Brown-Marx Building, completed in 1906, before the addition in 1907 that almost tripled the width of the building.

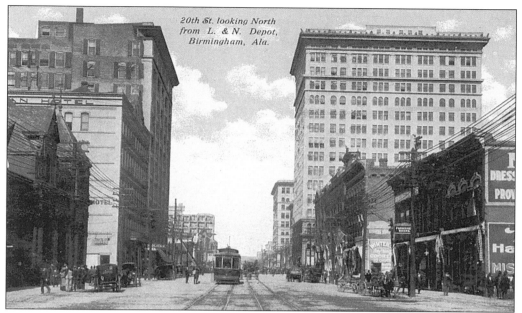

TWENTIETH STREET, LOOKING NORTH FROM L&N DEPOT. The addition to the Brown-Marx Building has been completed (1907), but the American Trust & Savings Bank Building has not been built (1912) on the southeast corner of the intersection at Twentieth Street and First Avenue. The L&N Depot can be seen in the left foreground.

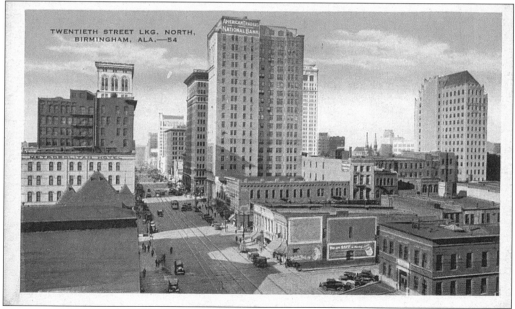

TWENTIETH STREET, LOOKING NORTH. This view from the L&N Depot shows that the American Trust & Savings National Bank has now been built (1912). After the completion of this building and the Brown-Marx Building, Empire Building, and Woodward Building on the other corners, it was proclaimed the "heaviest intersection in the world." The Protective Life Building (see page 13) can be seen on the far right.

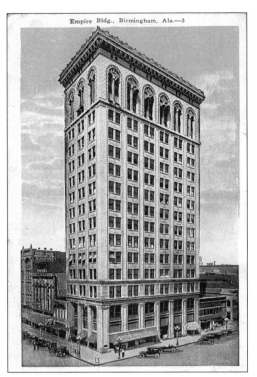

EMPIRE BUILDING, BIRMINGHAM, C. 1927.
The Empire Building, built in 1907, is on the northwest corner of First Avenue and Twentieth Street. To the left (west) down First Avenue is Chris Colias Café followed by Porters Department Store and Steele-Smith Department Store. Greene Drug Company is on the right side of the building facing Twentieth Street.

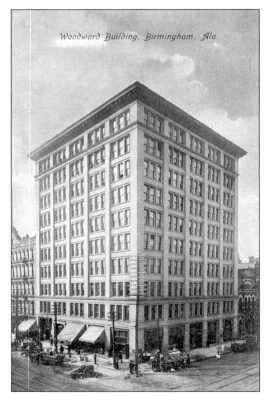

WOODWARD BUILDING, BIRMINGHAM.
The Woodward Building, built in 1901, is on the southwest corner of First Avenue and Twentieth Street. It was the first steel-framed commercial office building in Birmingham. The Metropolitan Hotel can be seen on the left.

BROWN-MARX BUILDING, BIRMINGHAM, C. 1910. The Brown-Marx Building, built in 1906, is shown after the 1907 addition. The Traders National Bank Building can be seen at the lower left of the view. The sender of this postcard has indicated that she lives on the eighth floor (see X on front of postcard).

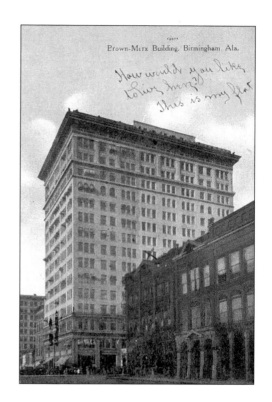

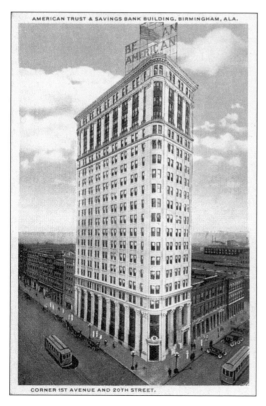

AMERICAN TRUST & SAVINGS BANK BUILDING, BIRMINGHAM. The American Trust & Savings Bank Building was the final building built at the intersection of First Avenue and Twentieth Street ("heaviest intersection on earth"). Built in 1912, it would later become the American-Traders Bank Building and finally the First National Bank of Birmingham. The Exchange Hotel can be seen on the right.

17

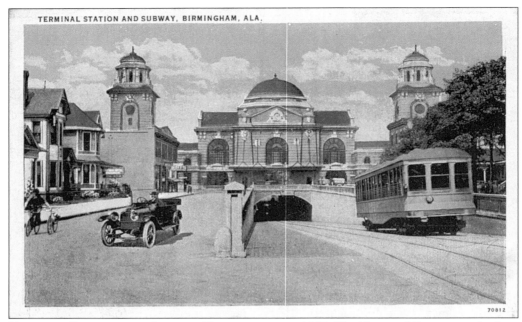

TERMINAL STATION AND SUBWAY, BIRMINGHAM, ALA.

70812

TERMINAL STATION AND SUBWAY, BIRMINGHAM, C. 1929. The Terminal Station was built in 1929 for all trains except the L&N (see below), which had a depot on Morris Avenue and Twentieth Street. By the mid-1920s, almost 100 passenger trains arrived and departed each day. The Terminal Hotel is located across the street from of the station. It was one of a half dozen located within a block of the station.

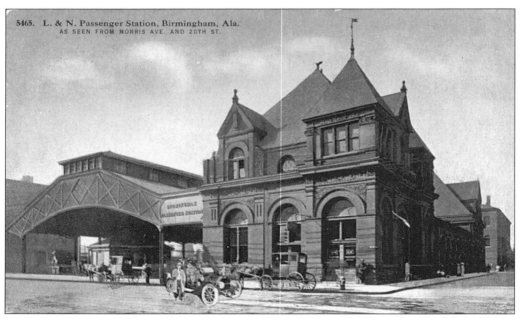

5465. L. & N. Passenger Station, Birmingham, Ala.
AS SEEN FROM MORRIS AVE. AND 20TH ST.

L&N PASSENGER STATION, BIRMINGHAM, C. 1918. The L&N Depot was built in 1886 to replace the old wooden Relay House. It served as the only train station until the Terminal Station (see above) was built in 1929. It is now the site of the Bank for Savings Building.

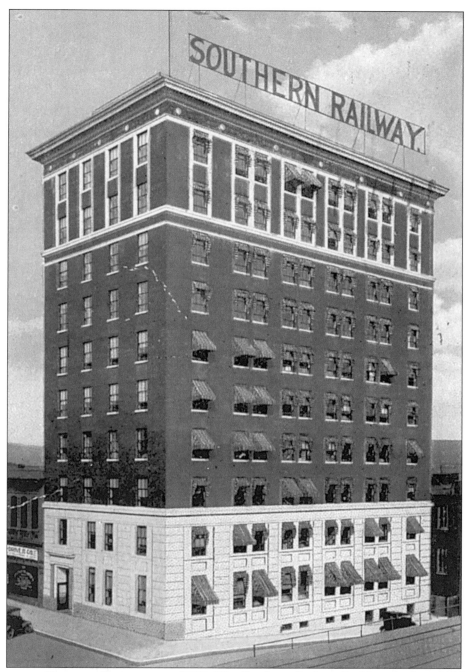

SOUTHERN RAILWAY BUILDING, C. 1929. The Southern Railway Building, built in 1929, was on the southeast corner of First Avenue and Twenty-second Street. The Southern Railroad had originally been the Georgia Pacific Railroad. At the lower right is the viaduct that goes over Morris Avenue and the railroad tracks. A car is seen going down beside the building toward Morris Avenue. On the left is the U-Drive It Company, an early rental car business in Birmingham.

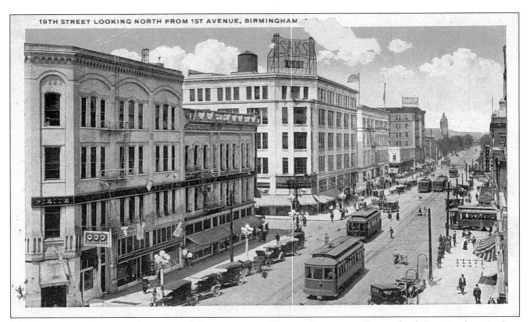

NINETEENTH STREET, LOOKING NORTH FROM FIRST AVENUE. Several of Birmingham's first department stores can be seen as you look north on Nineteenth Street from First Avenue. On the left foreground are Pizitz (1899), Saks (1895), and Loveman, Joseph & Loeb (1899). The Hillman Hotel, as well as the steeple of the First Methodist Church (see page 93), can be seen farther down the street.

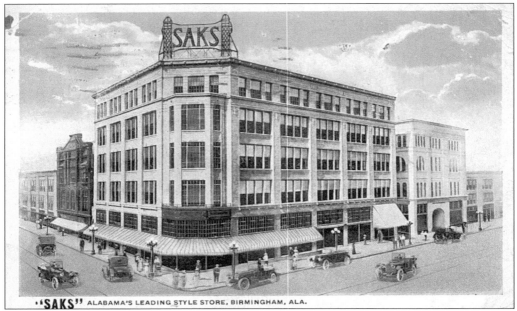

"SAKS" ALABAMA'S LEADING STYLE STORE, BIRMINGHAM, ALA.

SAKS, ALABAMA'S LEADING STYLE STORE, BIRMINGHAM. This is a closer view of Saks, which was located on the northwest corner of Nineteenth Street and Second Avenue. It was built on the site of the Florence Hotel (see page 103) and later became the J.J. Newberry Store.

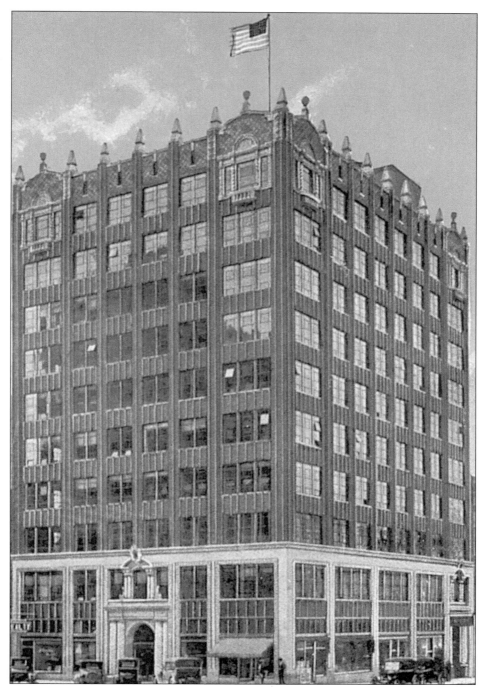

BANKERS BOND BUILDING. The Bankers Bond Building, built in 1920 by Richard W. Massey, was located at Twenty-first Street and Third Avenue. After the failure of Bankers Bond during the Depression, it was renamed the Massey Building. On the ground floor to the left is Charles R. Byrd & Company Real Estate, and at the right entrance to the building is the Patterson Retail Cigar Store.

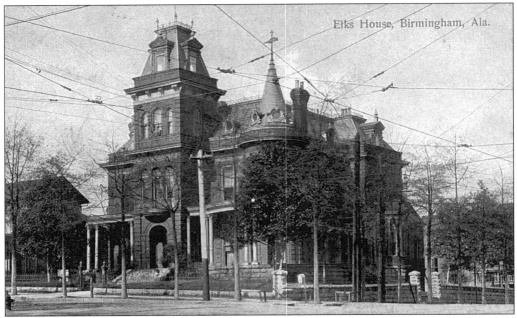

ELKS HOUSE, BIRMINGHAM, C. 1907. The Elks House was built in 1907 at 1830 Eighth Avenue to house the Birmingham Fraternal Order of Elks #79. The Municipal Auditorium (see page 81) was located across the street to the right. I recall this being a popular place for school club parties in the 1950s. Phillips High School was a few blocks away. This building was demolished and is now the site of the Birmingham School of Fine Arts.

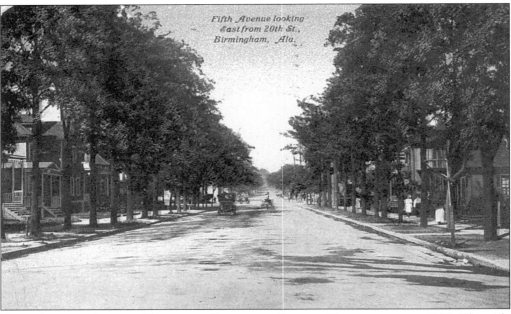

FIFTH AVENUE, LOOKING EAST FROM TWENTIETH STREET, BIRMINGHAM, C. 1910. The wide streets are lined with nice large residences as you look east down Fifth Avenue from Twentieth Street. This 1910 view is just east of the fashionable Southern Club (see page 26).

ALABAMA POWER COMPANY BUILDING, C. 1930. The Alabama Power Company building was built in 1925, and all materials used for construction came from within 60 miles. This included the structural steel, limestone, marble, brick, colored tile, cast-iron pipe, cement, lime, pine lumber, and slag cement. It was an early landmark with the "winged Mercury" statue on top of the building. It is located on the northwest corner of Sixth Avenue and Eighteenth Street.

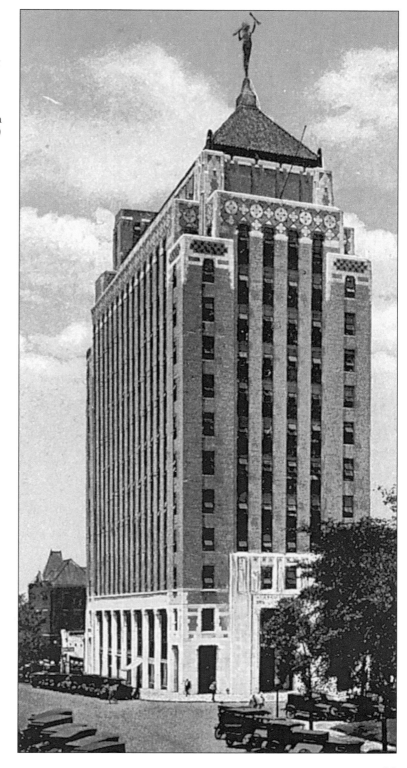

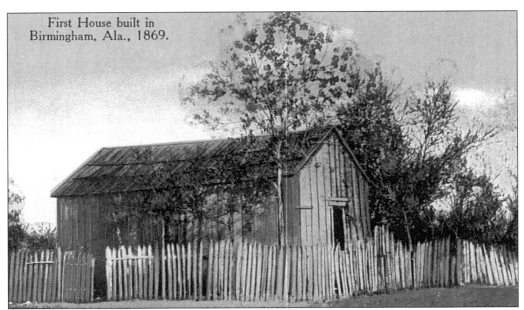

First House built in Birmingham, Ala., 1869.

FIRST HOUSE BUILT IN BIRMINGHAM, 1869. This house, built in 1869 by William Franklin Nabors, is reported to be the first house built in Birmingham. It was located on the southeast corner of First Avenue and Twenty-first Street and was torn down in 1890 to build the Steiner Brothers Bank. The 1883 Birmingham City Directory, in a short introduction to the report to Stockholders of the Elyton Land Company, indicates the first house erected was that of O.A. Johnson at the corner of Second Avenue and Nineteenth Street.

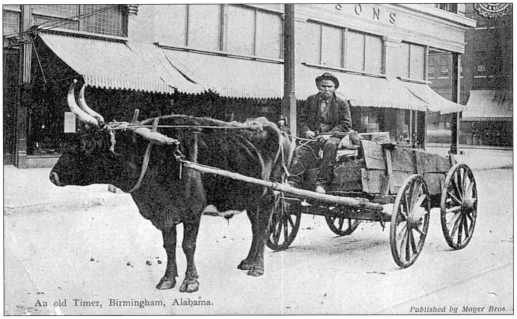

An old Timer, Birmingham, Alabama.

Published by Mayer Bros.

AN OLD TIMER, BIRMINGHAM. This view shows an "old timer" sitting on his ox wagon in front of the Blach & Sons Department Store. Note the homemade wagon tongue constructed from a slender tree.

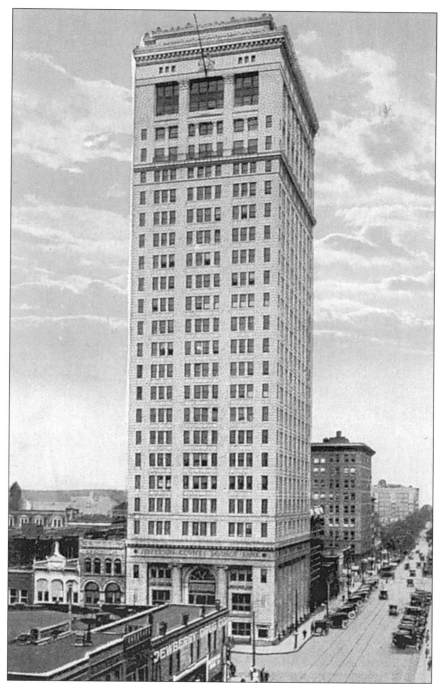

JEFFERSON COUNTY SAVINGS BANK, BIRMINGHAM, C.1924. Eugene F. Enslen built the Jefferson County Savings Bank Building on the northwest corner of Second Avenue and Twenty-first Street in 1924. At the time, this 25-story structure was the tallest building in Alabama. It later became the Comer Building and continued to be the tallest building in Alabama for many years.

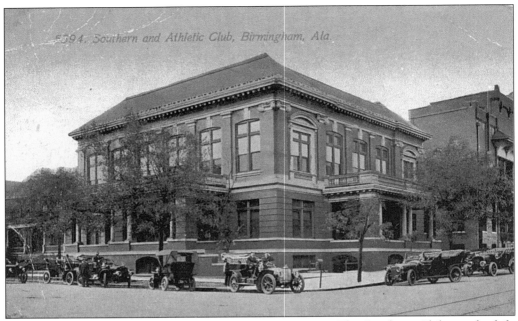

SOUTHERN AND ATHLETIC CLUB, BIRMINGHAM, C. 1912. The Southern Club, on the left, and the Athletic Club, on the right, were located on the northwest corner of Fifth Avenue and Twentieth Street in this 1912 view. Residences still lined Fifth Avenue at that time. The exclusive Athletic Club had been organized on August 5, 1886, and had been at several other locations on First Avenue and Morris Avenue, and in 1926, it was in the building on the northeast corner of Third Avenue and Twenty-third Street, currently the YWCA (see below and page 104).

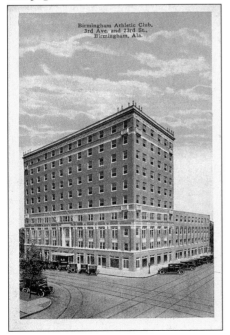

BIRMINGHAM ATHLETIC CLUB, BIRMINGHAM. This is the last known location for the Birmingham Athletic Club. This building, on the corner of Third Avenue and Twenty-third Street, became a Dixie-Carlton Hotel in the 1930s and then home to the YWCA in 1948 (see page 104).

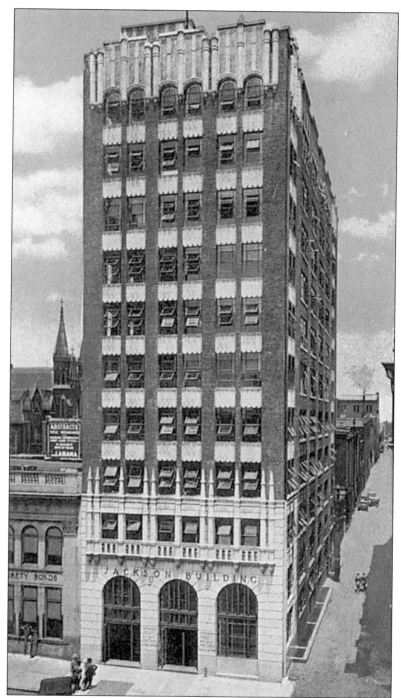

JACKSON BUILDING, BIRMINGHAM. The Jackson Building was located between Second and Third Avenue on Twenty-first Street, on the east side of the street next to the alley. It was built as the new home for the Jefferson County Building & Loan Association. On the left is the Jemison-Siebles Building, and in the background is St. Paul's Catholic Church.

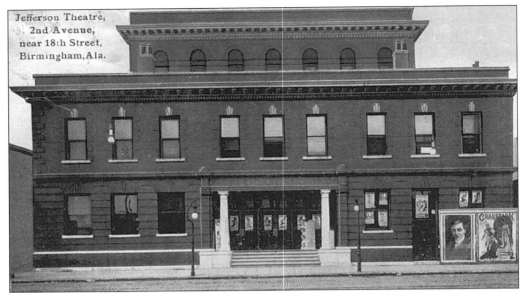

JEFFERSON THEATRE, BIRMINGHAM, C. 1917. The Jefferson Theatre, also know as the Erlanger-Jefferson Theatre, was located at 1710 Second Avenue. Notice the rather large playbills on the sidewalk. The Birmingham Hotel (see page 105) was just to the right on the corner.

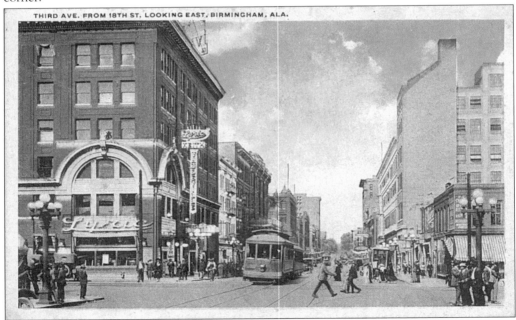

THIRD AVENUE FROM EIGHTEENTH STREET LOOKING EAST, BIRMINGHAM. This postcard view shows Third Avenue looking east from Eighteenth Street. The Lyric Theatre, built in 1912, can be seen on the left corner in the Lyric Building. The Lyric Theatre opened on January 14, 1914, and appearing there in the first year were Sophie Tucker, Buster Keaton, Mae West, Marx Brothers, Billie Burke, George Burns, and Fred Allen. The Alabama Theatre would be built a few years later on the other side of Third Avenue.

28

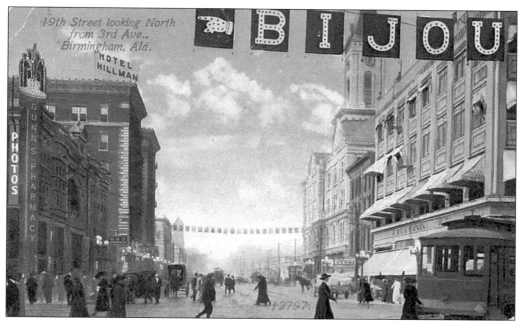

NINETEENTH STREET, LOOKING NORTH FROM THIRD AVENUE, BIRMINGHAM, C. 1925. This postcard, mailed in 1925, views Nineteenth Street looking north from Third Avenue. The Bijou sign above points to the Bijou Theatre two blocks to the west on Seventeenth Street. Gunn's Pharmacy can be seen at the left, and farther down the street is the Hillman Hotel (see page 105). On the right is the J. Blach & Sons Department Store, followed by the St. Charles Hotel and the Birmingham City Hall (see page 79).

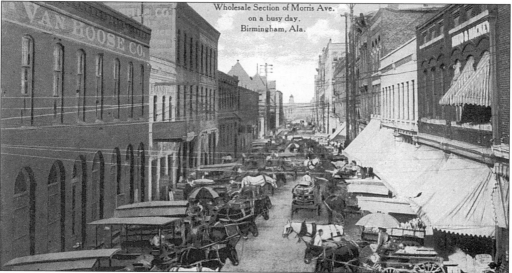

WHOLESALE SECTION OF MORRIS AVENUE ON A BUSY DAY, BIRMINGHAM. The wholesale section of the city was on Morris Avenue. This view is looking west toward the L&N Depot (visible in the background). The McLester-Van Hoose Company, C.F. Bell & Company, and Swift & Company can be seen on the left. On the right are Union Produce, Birmingham Produce, Greek-American Produce, J.J. Rogers Produce, and Copeland Produce.

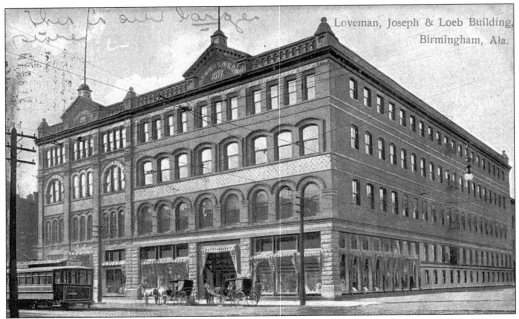

LOVEMAN, JOSEPH & LOEB BUILDING, BIRMINGHAM, C. 1908. This postcard of the Loveman, Joseph & Loeb building, mailed in 1908, is described by the sender as "our largest store." Loveman, Joseph & Loeb, established in 1899, was located at 212 Nineteenth Street. The Florence Hotel (see page 103) is to the left at the end of the block.

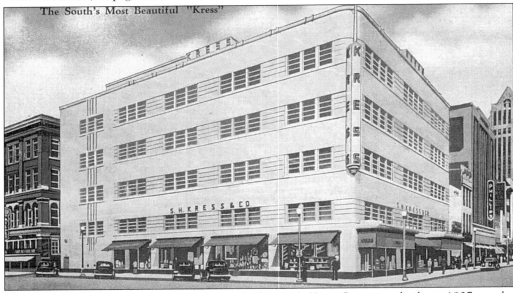

THE SOUTH'S MOST BEAUTIFUL "KRESS." This S.H. Kress Store was built in 1937 on the northeast corner of Third Avenue and Nineteenth Street. Their original store, built in 1915, was on Second Avenue between Nineteenth and Twentieth Streets. S.H. Kress produced a lot of postcards, many included in this book, but strangely enough, they did not publish this postcard depicting their own store. This postcard was published by the E.C. Kropp Company of Milwaukee.

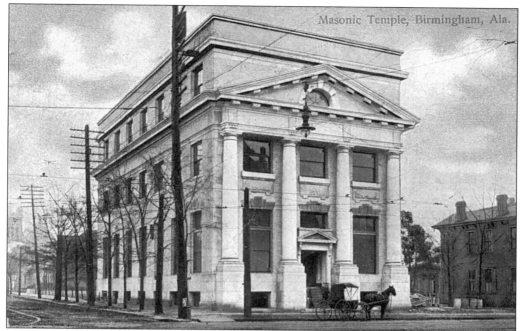

MASONIC TEMPLE, BIRMINGHAM, C. 1911. This 1911 postcard shows the old Masonic Temple building on the southeast corner of Sixth Avenue and Nineteenth Street. Notice the unpaved streets and the downtown buildings in the background. The horse and buggy, out front, was still a popular mode of travel.

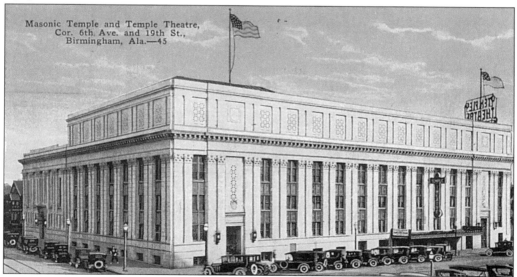

MASONIC TEMPLE AND TEMPLE THEATRE, BIRMINGHAM, C. 1926. In 1922, this Masonic Temple was built to replace the old building (pictured above) on the same site. It was originally used as administrative offices for the Masons, and in 1925, Loew's Theatre Company converted the auditorium into a vaudeville theater. Many of the popular vaudeville shows of the time appeared there. This building was demolished in 1970 to make way for the AmSouth-Harbert Plaza.

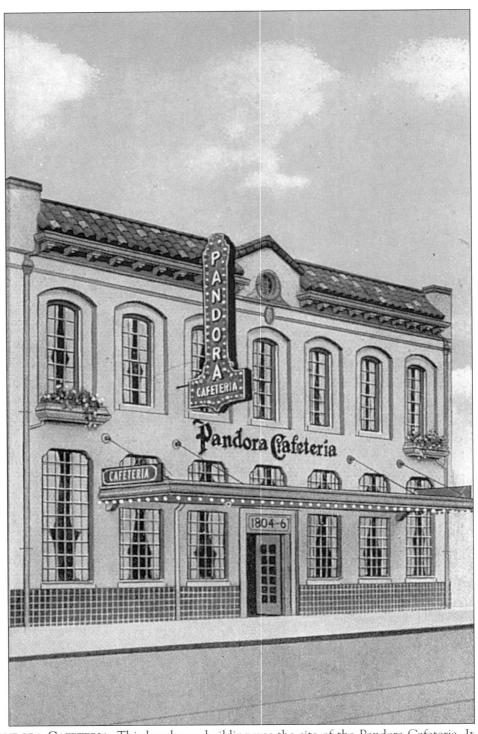

PANDORA CAFETERIA. This handsome building was the site of the Pandora Cafeteria. It was located at 1804 First Avenue in the 1920s and 1930s.

Two

NEIGHBORHOODS AND SURROUNDING COMMUNITIES

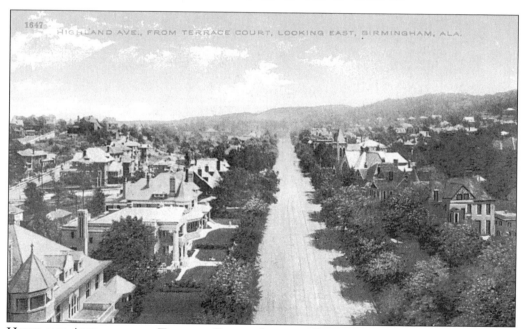

HIGHLAND AVENUE, FROM TERRACE COURT, LOOKING EAST, BIRMINGHAM. This is a view of South Highlands looking east on Highland Avenue from atop the Terrace Court Apartments (see next page). Notice the streets are still unpaved. A closer view of the houses in the left background is shown on the next page.

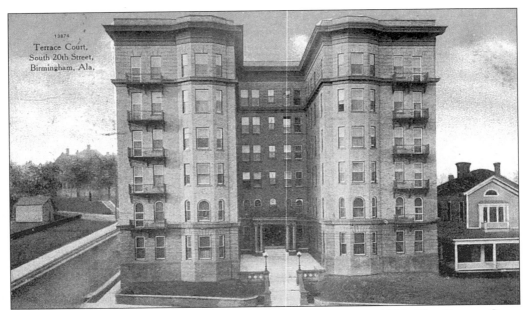

TERRACE COURT, SOUTH TWENTIETH STREET, BIRMINGHAM, C. 1909. The Terrace Court Apartment Building, the first high-rise apartments built in Birmingham and possibly the South, was built in 1908 by Col. Richard W. Massey. Adjacent to the courtyard was a bar and restaurant, where President Woodrow Wilson ate when he visited Birmingham. The second floor had billiard and card rooms for men. A roof garden and dining room were located on top of the building.

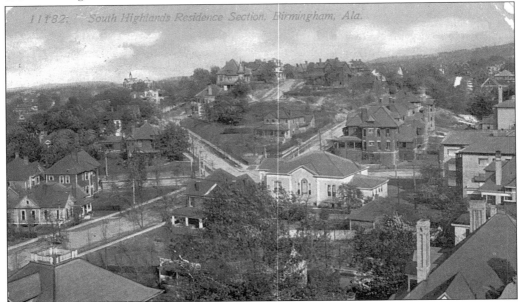

SOUTH HIGHLANDS RESIDENCE SECTION, BIRMINGHAM, C. 1916. Another view of the South Highlands neighborhood shows some of the large fine homes of that area. South Highlands was a separate town before merging with the city of Birmingham in 1910. These houses are located just behind Highland Avenue, which is to the right.

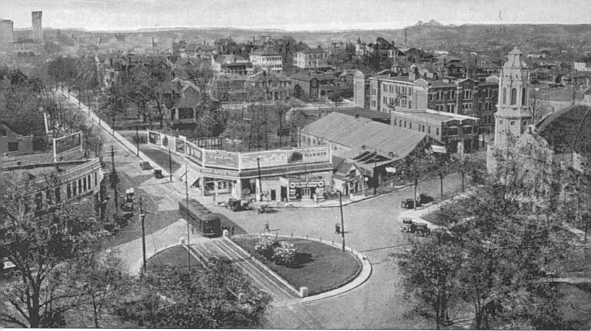

Five Points, looking North from Terrace Court Apt., Birmingham, Ala.—27

FIVE POINTS, LOOKING NORTH FROM TERRACE COURT APARTMENTS, BIRMINGHAM. This view is looking down on Five Points, a hub of activity in South Highlands, from the roof of the Terrace Court Apartments. Streetcars brought people from the city center up Twentieth Street to this early neighborhood. South Highlands School (see page 68), built in 1907, can be seen at the upper right. Five Points Methodist Church (see page 94), built in 1909, is to the far right.

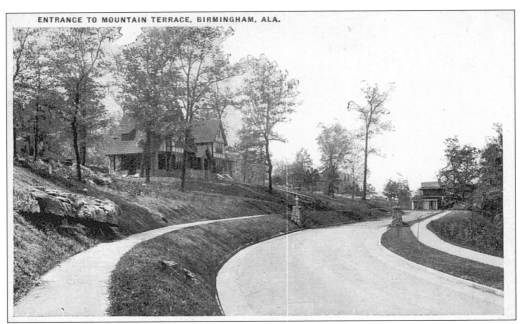

ENTRANCE TO MOUNTAIN TERRACE, BIRMINGHAM, ALA.

ENTRANCE TO MOUNTAIN TERRACE, BIRMINGHAM. This is one of the entrances to Mountain Terrace, a development by Robert Jemison Jr. in 1906. It consisted of about 30 acres east of Lakeview and south of Avondale. These houses, pictured here along with the two rock posts, are still there.

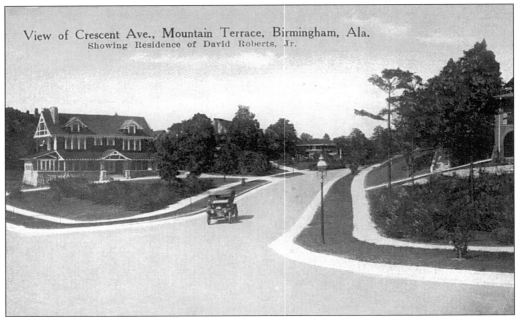

View of Crescent Ave., Mountain Terrace, Birmingham, Ala.
Showing Residence of David Roberts, Jr.

A VIEW OF MOUNTAIN TERRACE, BIRMINGHAM. Another view of Mountain Terrace shows Crescent Avenue. Many early Birmingham leaders and businessmen lived here, such as Oscar Wells, David Roberts, Jelks Cabaniss, Jack Bowron, and, of course, the developer, Robert Jemison Jr., who lived at 3830 Crescent Road.

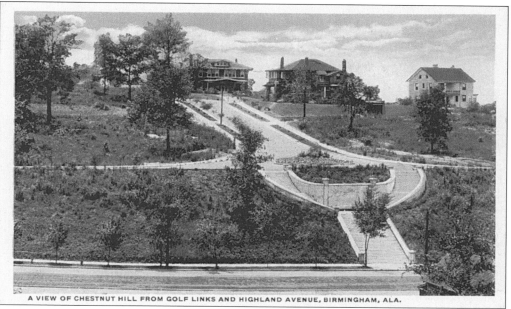

A VIEW OF CHESTNUT HILL FROM GOLF LINKS AND HIGHLAND AVENUE, BIRMINGHAM, ALA.

A VIEW OF CHESTNUT HILL FROM THE GOLF LINKS AND HIGHLAND AVENUE, BIRMINGHAM. Chestnut Hill was located across from Lakeview Park, directly in front of the lake and the golf course. The street shown here, above Highland Avenue, is an optical illusion, and what is going uphill looks and feels like it is going downhill. It was listed in *Ripley's Believe It or Not* as "Gravity Hill." The three houses on top of the hill remain today, and the one on the left is still in the original owner's family.

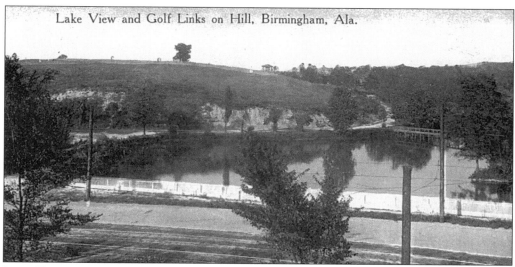

Lake View and Golf Links on Hill, Birmingham, Ala.

LAKE VIEW AND GOLF LINKS ON HILL, BIRMINGHAM. This is a view of Lakeview Park showing the lake and golf course. The Elyton Land Company had laid out 43 acres in 1884 for a park. Here, a hotel located to the left of the lake burned in the 1890s. The Birmingham Country Club, organized in North Birmingham in 1899, moved here in 1904. When the country club later moved to Shades Mountain, the golf course was operated by the city of Birmingham and renamed after Charlie Boswell, repeat National Blind Golf Champion.

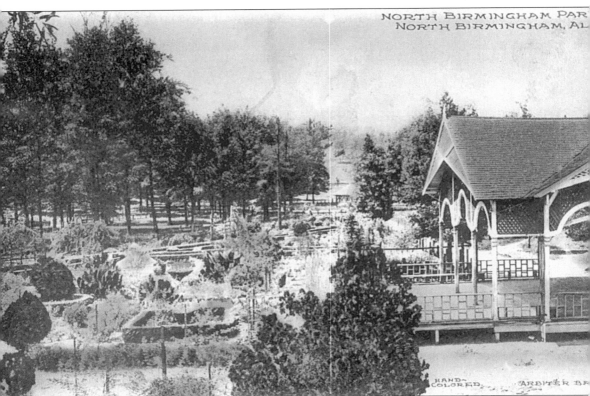

NORTH BIRMINGHAM PARK. The town of North Birmingham, which was developed by the North Birmingham Land Company in 1886, opened North Birmingham Park in 1895. The North Birmingham Land Company had purchased 900 acres of land, originally a part of the Alfred Nathaniel Hawkins plantation. They also developed the first golf course in Jefferson County in the town of North Birmingham in 1899. The park also became the home of an exclusive gun club that same year. In addition to tennis courts, a swimming pool was added around 1930.

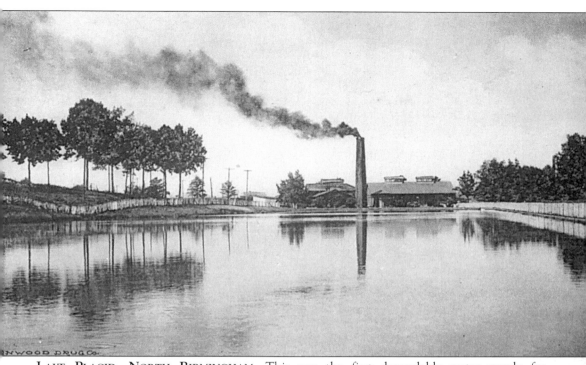

LAKE PLACID, NORTH BIRMINGHAM. This was the first dependable water supply for Birmingham, opened May 1873, and it was located in the city of North Birmingham. Village Creek supplied the water, and this pumping station pumped water to the top of a hill at Thirteenth Avenue and Twenty-second Street North. It was then gravity fed to the downtown area. When more water was needed than Village Creek could provide, a canal was dug from Five-Mile Creek to bring additional water to the pumping station. Portions of the old canal can still be seen in the Tarrant/Boyles area, east of Birmingham. This station remained in service until 1938, and evidence of the walls and foundation are still visible. The site is now vacant; however, an automobile shredder business operated there for a number of years until recently.

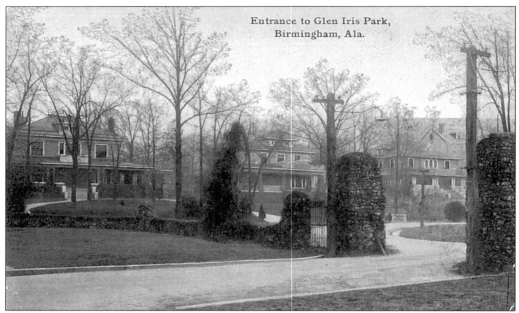

ENTRANCE TO GLEN IRIS PARK, BIRMINGHAM. Robert Jemison Sr., the founder of the Birmingham Railway, Light and Power Company, developed Glen Iris Park around 1901. This exclusive development was highly restrictive and consisted of 14 homes built on two or more acre tracts. The homes surrounded a large central park in a horseshoe pattern.

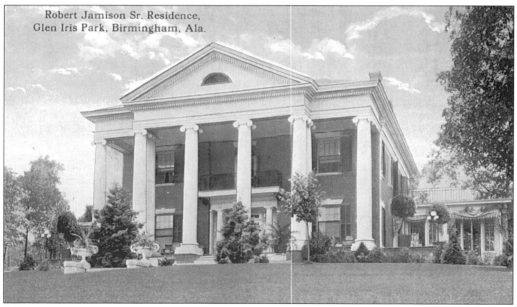

ROBERT JEMISON SR. RESIDENCE, GLEN IRIS PARK, BIRMINGHAM. Robert Jemison Sr. built this large two-story house in Glen Iris in 1902. Some of the other early residents of Glen Iris were Robert Montgomery Goodalls, James M. Gillespy, William Yancey, Henry DeBardeleben, and Rutherford DuPont Thompson. Note that the name is misspelled as "Jamison" on the postcard.

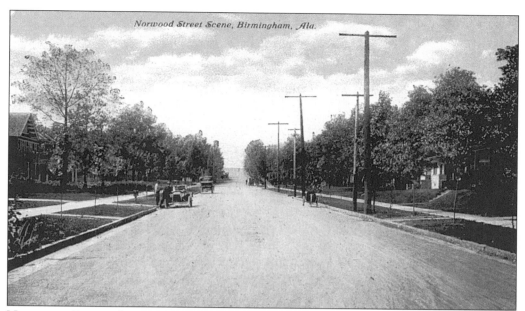

NORWOOD STREET SCENE, BIRMINGHAM. Norwood was the first development by the newly formed Birmingham Realty Company, formerly Elyton Land Company. Streetcar service had been extended to Norwood by the 1890s, and they hoped to replicate the success of the Highland Avenue development. The community was named for Stanley Norwood, founder of American Grain Company, mayor of West End, real estate investor, and a friend of the president of Birmingham Realty Company.

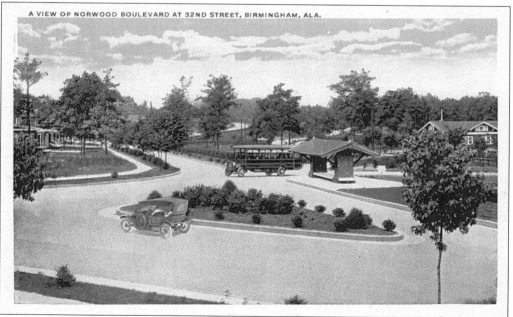

A VIEW OF NORWOOD BOULEVARD. This is a view of Norwood Boulevard, a spacious street separated by a beautifully landscaped parkway. By 1913, almost 100 homes had been built along the boulevard. Most of the houses still exist but are in a state of disrepair.

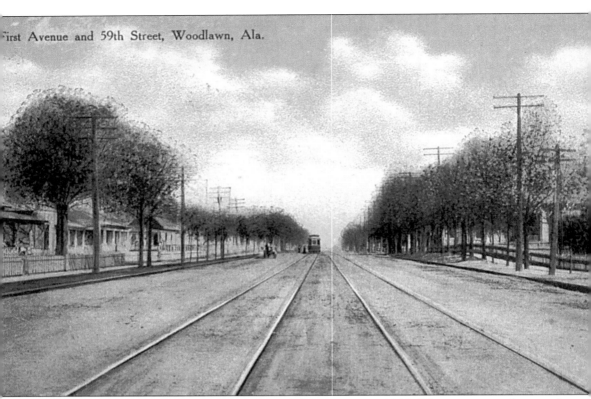

First Avenue and 59th Street, Woodlawn, Ala.

FIRST AVENUE AND FIFTY-NINTH STREET, WOODLAWN, C. 1910. This is a postcard view of Woodlawn, incorporated 1891, looking east down First Avenue from Fifty-ninth Street. A streetcar can be seen in the distance and is probably coming or going to East Lake Park, which is several miles east of Woodlawn. Woodlawn was named for Obadiah Wood, whose father, Edmund Wood, had settled there in 1824. The first post office was called Rockville and then Wood Station. The Woodlawn City Hall building, on First Avenue near Fifty-fifth Place, still remains.

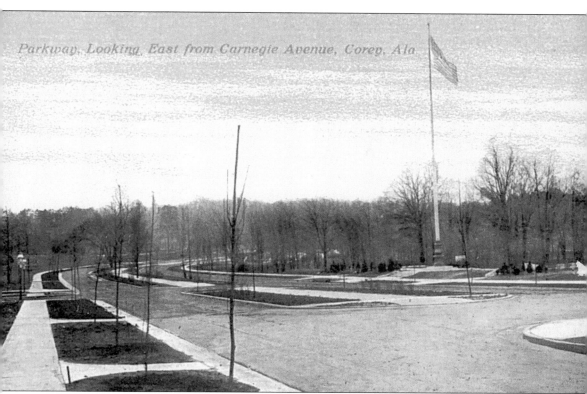

Parkway, Looking East from Carnegie Avenue, Corey, Ala.

PARKWAY, LOOKING EAST FROM CARNEGIE AVENUE, COREY, ALABAMA. This is how Corey, renamed Fairfield in 1913, looked as it was being developed by Robert Jemison Jr. for U.S. Steel. In 1909, plans were drawn to convert 240 acres of cotton fields and woods into a model industrial development. Willie Mays, of baseball fame, grew up in Fairfield and lived at 5507 Avenue G.

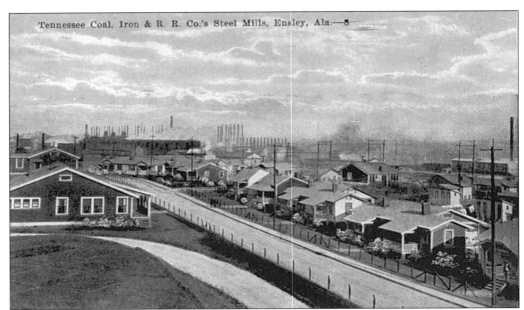

TENNESSEE COAL, IRON & RAILROAD COMPANY'S STEEL MILLS, ENSLEY, ALABAMA. This is a view of residential housing in Ensley with the Tennessee Coal, Iron & Railroad steel mills in the background. Enoch Ensley, who had purchased a large amount of land and formed the Ensley Land Company, began the development of Ensley in 1886. He had great plans to build parks, racetracks, lakes, tramways, railroads, and a waterworks. Unfortunately, Ensley died in 1891 before ever selling a lot.

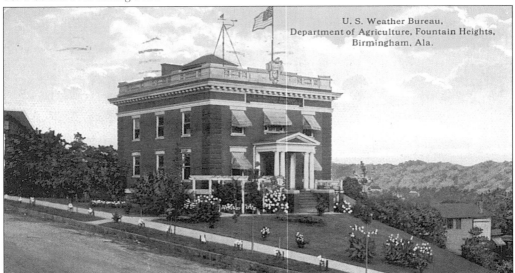

U. S. Weather Bureau,
Department of Agriculture, Fountain Heights,
Birmingham, Ala.

U.S. WEATHER BUREAU, DEPARTMENT OF AGRICULTURE, FOUNTAIN HEIGHTS, c. 1913. Fountain Heights was a neighborhood just northwest of the downtown section of Birmingham. Shown here is a building that housed the U.S. Weather Bureau and the Department of Agriculture. The building was most likely chosen for its elevation. Fountain Heights, primarily a residential area, was one of many communities that sprang up around Birmingham during its rapid growth.

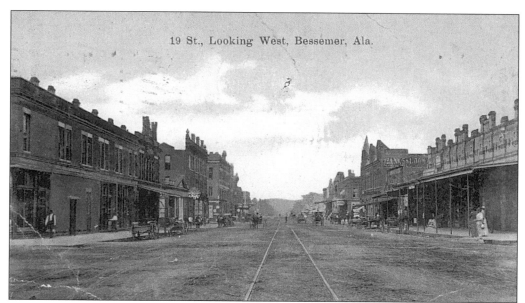

NINETEENTH STREET, LOOKING WEST, BESSEMER, C. 1910. The Bessemer Coal, Iron & Land Company, which was owned by the DeBardeleben Coal & Iron Company, founded Bessemer in the late 1880s. By 1887, Bessemer had 1,000 people, and construction had begun for street improvements, a waterworks, streetcar railroads, and a schoolhouse. This is a 1910 postcard view of Nineteenth Street, looking west. The message on the reverse says "a small town I visited today—doing a nice business."

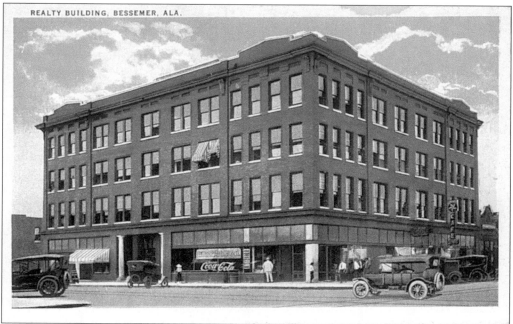

REALTY BUILDING, BESSEMER, ALABAMA. The Realty Building, constructed in 1915, was located at 300 Nineteenth Street in Bessemer. On the corner is Louis Read Drug, and down to the right is the Bright Star Café. By 1920, the population of Bessemer had grown to 18,674.

45

LAKE AT HOME OF HUGH MORROW, ROEBUCK SPRINGS, C. 1920. This 1920 view shows the home of Hugh Morrow in Roebuck Springs, which was located between Woodlawn and Huffman. Roebuck gets its name from George Roebuck, who had a large plantation at the intersection of Blount Springs Road and Huntsville Road. The Birmingham Boys Industrial School is located on the site now.

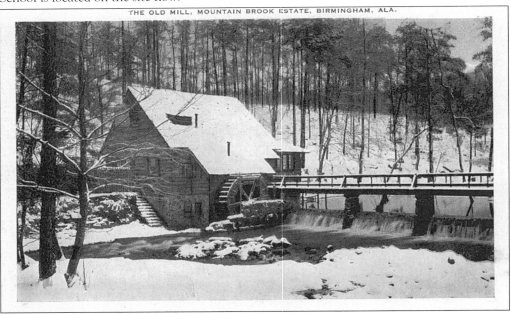

THE OLD MILL, MOUNTAIN BROOK ESTATES, BIRMINGHAM. Robert Jemison Jr. built the Old Mill House as an attraction for his new development of Mountain Brook Estates in 1926. It was a replica of the first gristmill in the area, which had been destroyed by a flood, leaving only the old stone wall. It was used first as a tea room, then a restaurant, and now has been converted into a private residence.

Three

STEEL, COAL AND IRON ORE MINING, AND OTHER INDUSTRIES

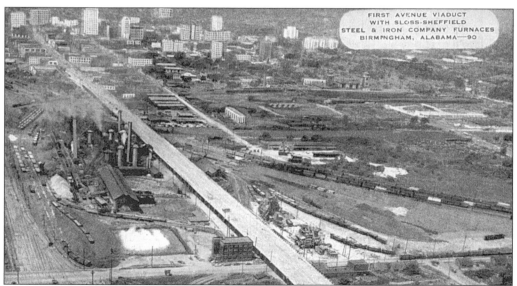

FIRST AVENUE VIADUCT WITH SLOSS-SHEFFIELD STEEL & IRON COMPANY FURNACES. This is a view of the Sloss Furnace, located along the First Avenue viaduct at Thirty-second Street, North. James Withers Sloss formed the Sloss Furnace Company in 1881 and went into blast with the first furnace in 1882. A second furnace was added the next year, and the two had a daily output of 360-400 tons of pig iron. It ceased operation in 1971 and, after renovation and restoration, is now a museum paying tribute to the iron-making process.

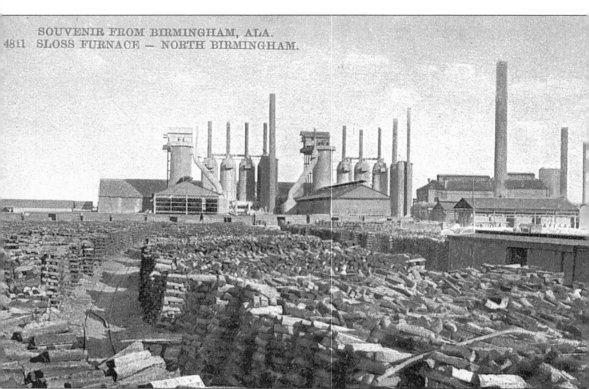

SLOSS FURNACE, NORTH BIRMINGHAM. Sloss also built two furnaces in North Birmingham that began operation in 1887, just east of Twenty-seventh Street at Twenty-fourth Avenue. These furnaces, combined with the two on First Avenue, produced 175,000 tons of foundry and mill pig iron annually by 1892 and, in 1894, started to export to Europe, Australia, Japan, and South America. This is an earlier view, when charcoal was used to fire the furnaces. Note the stacks of wood for making the charcoal. Operations here were discontinued in the 1950s.

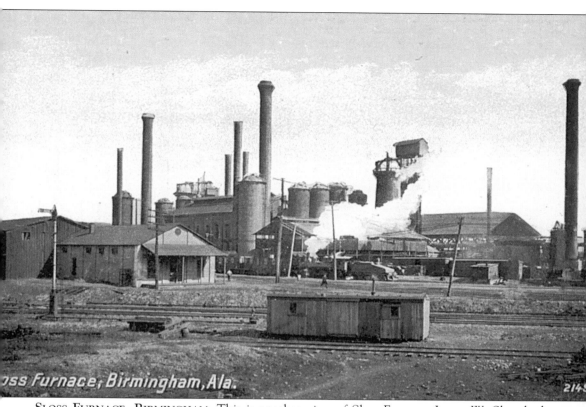

Sloss Furnace, Birmingham, Ala.

2148

SLOSS FURNACE, BIRMINGHAM. This is another view of Sloss Furnace. James W. Sloss had started the company with capital advanced by the L&N Railroad. He had previously purchased 50 acres of land along First Avenue between the tracks of the L&N and Alabama Great Southern Railroads. Later, he purchased 38,000 acres of mineral land, much of it ore land on Red Mountain. Sloss sold his interests in 1886 to John W. Johnston, president of the Georgia Pacific Railroad, and Joseph F. Johnston, president of the Alabama National Bank.

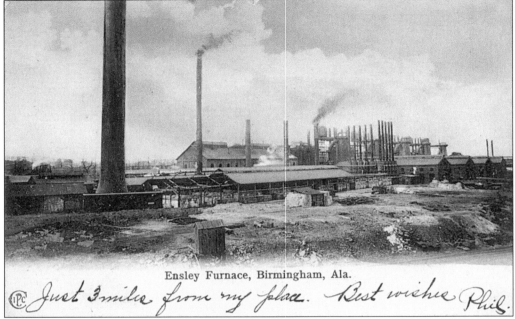

Ensley Furnace, Birmingham, Ala.

Just 3 miles from my place. Best wishes Phil.

ENSLEY FURNACE, C. 1908. The Tennessee Coal, Iron & Railroad Company began an open-hearth furnace at Ensley, and the first steel was tapped on Thanksgiving Day, 1899. This postcard was mailed in 1905, the same year the last of six blast furnaces were added.

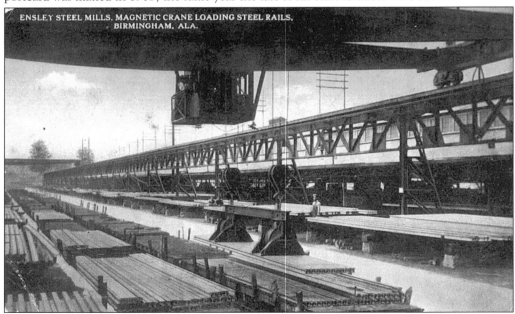

ENSLEY STEEL MILLS, MAGNETIC CRANE LOADING STEEL RAILS, BIRMINGHAM, ALA.

ENSLEY STEEL MILLS, MAGNETIC CRANE LOADING STEEL RAILS, C. 1916. This postcard, mailed in 1916, shows a magnetic crane loading steel rails at the Ensley Steel Mills, which had begun rail production in 1902. By 1916, the population of the town of Ensley had grown to over 25,000. Ensley, like most of the other towns surrounding Birmingham, had become a part of the city of Birmingham in 1910.

50

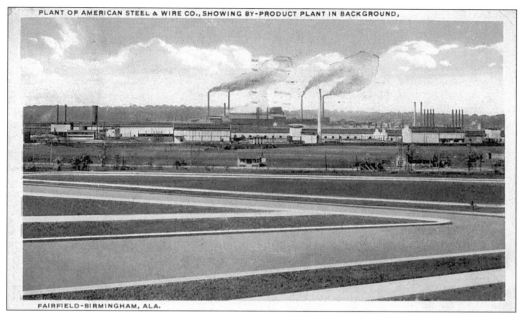

FAIRFIELD-BIRMINGHAM, ALA.

PLANT OF AMERICAN STEEL & WIRE COMPANY, FAIRFIELD, C. 1920. This postcard, with a view of the American Steel & Wire Company plant in Fairfield, was mailed in 1920. This plant made wire for barbed wire fences, wire fences, nails, staples, and rods from 1914 until 1979.

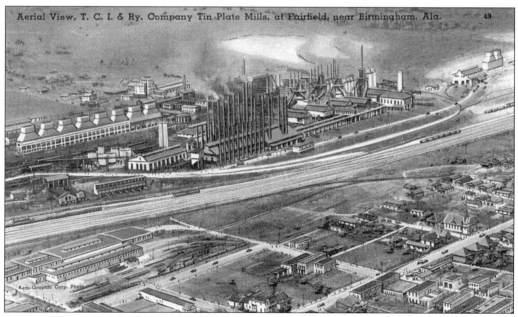

Aerial View, T. C. I. & Ry. Company Tin Plate Mills, at Fairfield, near Birmingham, Ala. 43

AERIAL VIEW, T.C.I. & RAILROAD COMPANY TIN PLATE MILLS, FAIRFIELD. This is the Tennessee Coal Iron & Railroad Company's Tin Plate Mill at Fairfield as seen from the air. Note the residences, businesses, and church located near the plant. The company started a health care program in 1913 and hired Dr. Lloyd Noland to run it. A 318-bed hospital was completed in 1919 (see page 86).

51

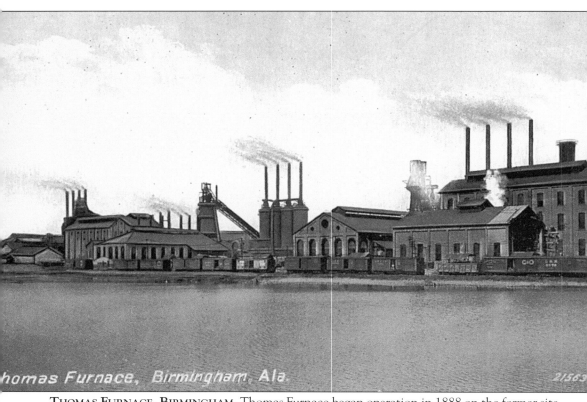

Thomas Furnace, Birmingham, Ala.

21563

THOMAS FURNACE, BIRMINGHAM. Thomas Furnace began operation in 1888 on the former site of the Williamson Hawkins Plantation, which dated from the 1820s. The Thomas site, including the plant and housing for employees, was surrounded by the tracks of the Birmingham Southern, Frisco, and L&N Railroads. By 1912, almost 600 workers and their families lived there. Many of these houses for workers are still being used, as well as churches and stores. This site can be accessed directly across U.S. Highway 78 West from the Alabama State Highway Department, west of the intersection with Finley Avenue.

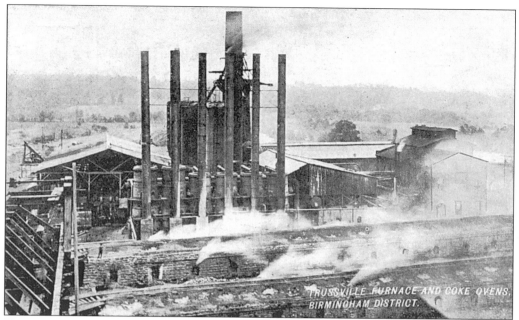

TRUSSVILLE FURNACE AND COKE OVENS, BIRMINGHAM DISTRICT. The Birmingham Furnace and Manufacturing Company, incorporated in 1886 with capital of $1.5 million, purchased land in Trussville to build a furnace. The Trussville Furnace was blown in 1889, and the town of Trussville, settled by Warren Truss in 1821, grew rapidly. The Trussville Furnace site, which discontinued operation in 1918, is east of Hewitt-Trussville High School.

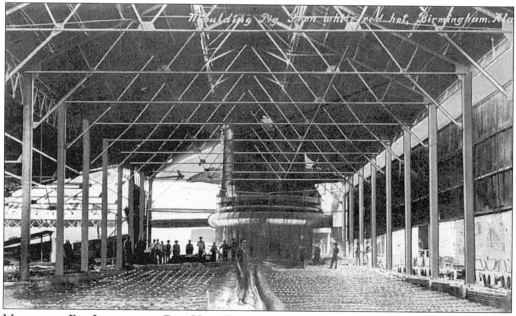

MOULDING PIG IRON WHILE RED HOT, BIRMINGHAM. This postcard, produced by S.H. Kress & Company, shows an unidentified site where pig iron is being molded. Kress & Company produced local view postcards for sale in their stores. About a dozen are included in this book.

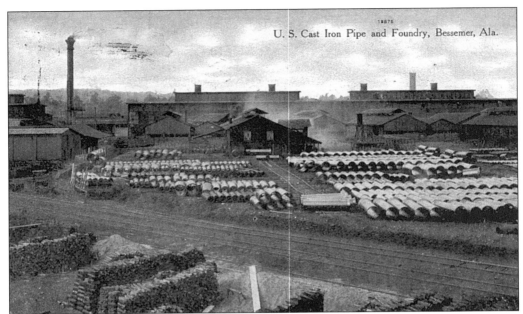

U.S. Cast Iron Pipe and Foundry, Bessemer, Ala.

U.S. CAST IRON PIPE AND FOUNDRY, BESSEMER. This is a view of the U.S. Cast Iron Pipe and Foundry in Bessemer. By 1923, this plant, along with the other cast iron pipe plants in the area, produced 400,000 tons of pipe, which was about half of the total produced in the United States.

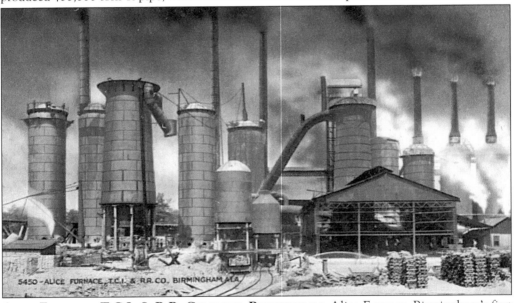

5450 - ALICE FURNACE, T.C.I. & R.R. CO. BIRMINGHAM ALA.

ALICE FURNACE, T.C.I. & R.R. COMPANY, BIRMINGHAM. Alice Furnace, Birmingham's first pig iron furnace, went into blast in 1880. Henry DeBardeleben and T.T. Hillman, grandson of the builder of the Tannehill Furnaces, built this furnace. Alice Furnace, named for Debardeleben's oldest daughter, was located on 20 acres at the western edge of the city between Eighth and Tenth Streets, south of Morris Avenue and the railroad tracks. The first Birmingham Barons baseball team played on a field, called the "Slag Pile," north of the railroad tracks by the Alice Furnace.

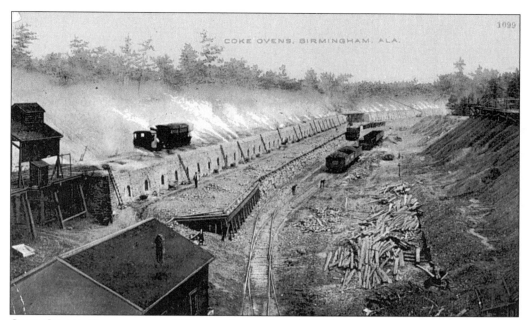

COKE OVENS, BIRMINGHAM. This view shows a long line of coke ovens, used to turn coal into coke, spewing their hot gases. During this process, coal is heated above 2,000 degrees Fahrenheit for 13 to 18 hours. In 1917, Alabama produced 4.8 million tons of coke, with the bulk of it from the Birmingham District.

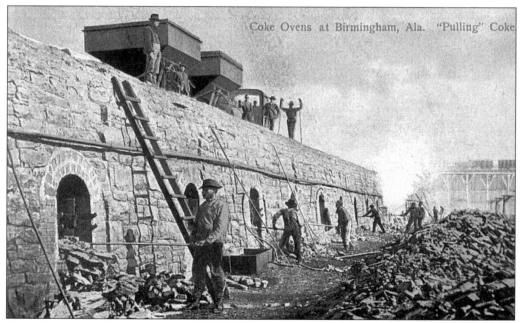

COKE OVENS AT BIRMINGHAM, C.1908. This postcard, mailed in 1908, gives a closer view of the "beehive" coke ovens. By the time this card was mailed, there were 40 companies operating 143 coal mines in the area, with most of the coal going to coke ovens.

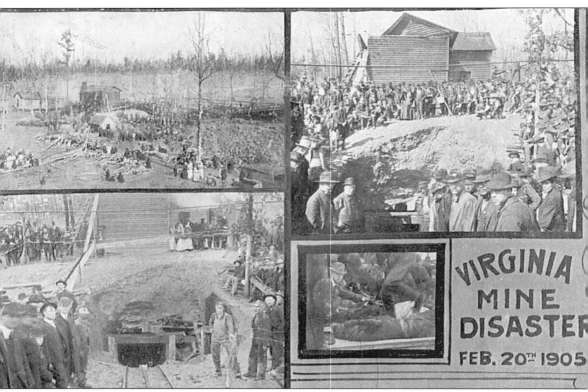

VIRGINIA MINE DISASTER, FEBRUARY 20, 1905. The Virginia Mine, one of over 100 operating in the Birmingham District, was located 17 miles southwest of Birmingham and 3.5 miles west of Bessemer. This postcard shows 4 views of an explosion that occurred on February 20, 1905, killing 106 men and 20 mules. Industrial accidents, such as this, were not uncommon at the turn of the 20th century.

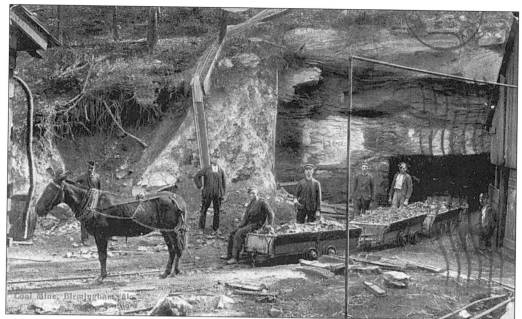

COAL MINE, BIRMINGHAM, C. 1907. This postcard, mailed in 1907, depicts a coal mine typical of many located in the area surrounding Birmingham. Coal was dug by hand with pick axes and hauled out by mule-powered wagons on rails. Convicts, leased to the mine owners, worked many of the early mines.

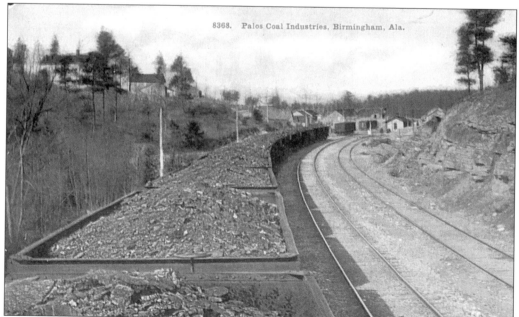

PALOS COAL INDUSTRIES, BIRMINGHAM. Palos Mine was located in west Jefferson County, near Graysville. This postcard view, *c.* 1915, shows rail cars loaded with coal from the Palos Mine. Houses for workers can be seen nearby. It was common for industries to make housing available for workers close to the workplace.

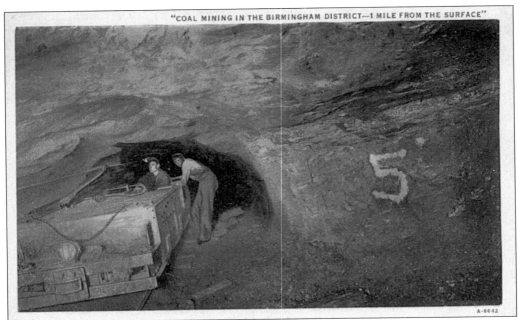

COAL MINING IN THE BIRMINGHAM DISTRICT—1 MILE FROM THE SURFACE. Another view of an underground coal mine, as the caption says, is 1 mile below the surface. In some areas, there was barely enough room for miners to stand erect.

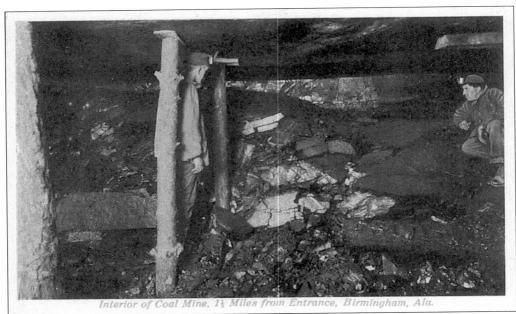

Interior of Coal Mine, 1½ Miles from Entrance, Birmingham, Ala.

INTERIOR OF COAL MINE, BIRMINGHAM. This pre-1915 postcard displays another view of the interior of a coal mine. Note the tree timbers used to shore up and support the ceiling of the mine. Coal mining was very dangerous work, and most mines were unable to avoid terrible disasters (see page 56).

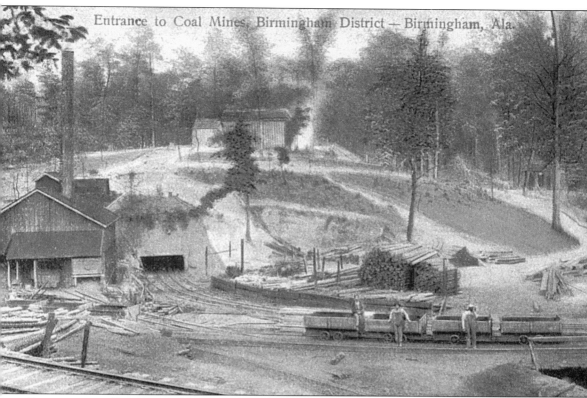

ENTRANCE TO COAL MINES, BIRMINGHAM DISTRICT. An unidentified coal mine illustrates a typical outside scene. Note the wood timbers stacked outside for use as roof supports inside the mine (see previous page). The first regular mining of coal in Alabama was in 1856 at nearby Shelby County by the Alabama Coal Mining Company. An 11-ton lump of coal, from the Pratt Coal & Coke Company, was displayed at the New Orleans Industrial and Cotton Exhibition of 1884 to illustrate the rich mineral resources of the region. By 1914, the Birmingham District had become the seventh largest coal producer in the nation.

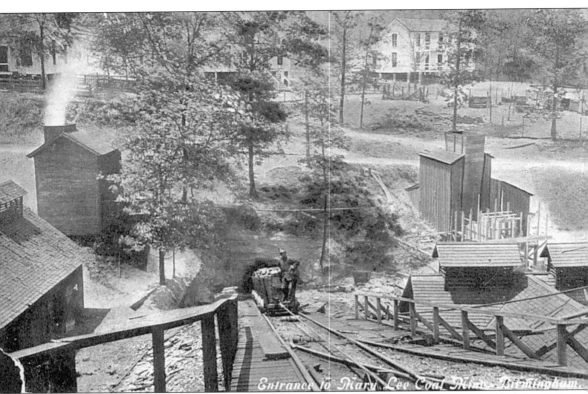

ENTRANCE TO MARY LEE COAL MINE, BIRMINGHAM, C. 1913. This postcard, mailed in 1913, shows the Mary Lee Coal Mine, located in the Lewisburg area north of Birmingham. Bartholomew Boyles, who started the mine along with other related industries, named this mine, a coal seam, and his mining railroad for his daughter, Mary Lee. Boyles sold his mine to the Alabama Consolidated Coal Company about 1899. The mine superintendent's residence is still standing along Highway 31 in Fultondale.

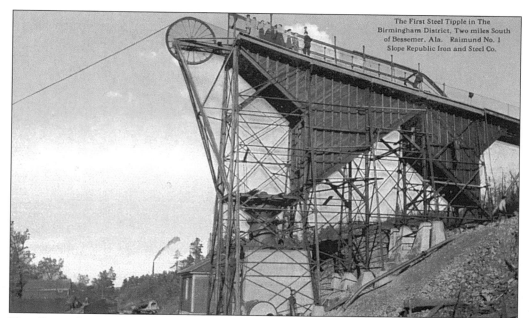

The First Steel Tipple in The Birmingham District, Two miles South of Bessemer, Ala. Raimund No. 1 Slope Republic Iron and Steel Co.

THE FIRST STEEL TIPPLE IN THE BIRMINGHAM DISTRICT. The Raimund Mine, named for Samuel Thomas's grandson, was opened in 1896 on the Birmingham Mineral Railroad near Bessemer. Republic Steel purchased the mine in 1899 and operated it until 1944, when it was sold to a real estate firm. By 1938, the mine had produced 12 million tons of red iron ore.

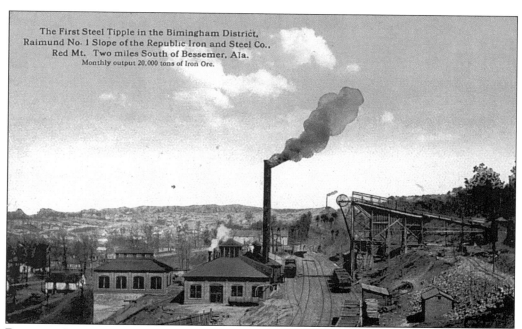

The First Steel Tipple in the Bimingham District, Raimund No. 1 Slope of the Republic Iron and Steel Co., Red Mt. Two miles South of Bessemer, Ala. Monthly output 20,000 tons of Iron Ore.

RAIMUND NO. 1 SLOPE OF THE REPUBLIC IRON AND STEEL COMPANY, RED MOUNTAIN. This postcard shows a panoramic view of the Raimund Mine and describes it as having the first steel tipple in the Birmingham District. It also indicates a monthly output of 20,000 tons of iron ore.

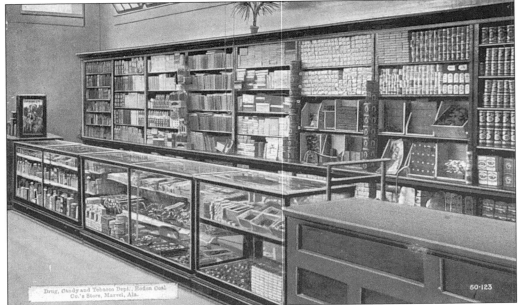

Roden Coal Company's Store, Marvel, Alabama, c. 1919. This postcard, mailed in 1919, shows the interior of the company store of the Roden Coal Company in Marvel, Alabama, located in nearby Bibb County. This is the drug, candy, and tobacco department of the store. Company stores carried everything needed for the worker's family, and items could be bought "on account," where purchases were deducted from the employee's salary.

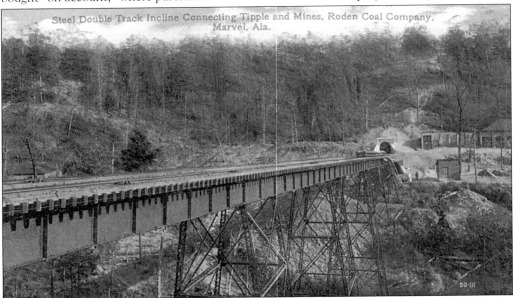

Steel Double Track Incline Connecting Tipple and Mines, Roden Coal Company. Benjamin F. Roden owned the Roden Coal Company. He was active in many developments in the area, including the first streetcar railway, the town of Avondale, banks, real estate, and, of course, mines. He also owned the Valley View Mine, which mined iron ore located beneath the current site of The Club.

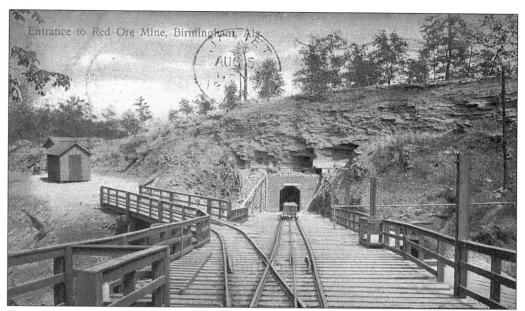

ENTRANCE TO RED ORE MINE, BIRMINGHAM. This postcard shows an entrance to an unidentified red iron ore mine. This is probably one of 100 or more red iron ore mines located on Red Mountain alone. The message on the back of this postcard indicates that it was sent in a trade and says that two or three cards in an envelope will get a return, card for card.

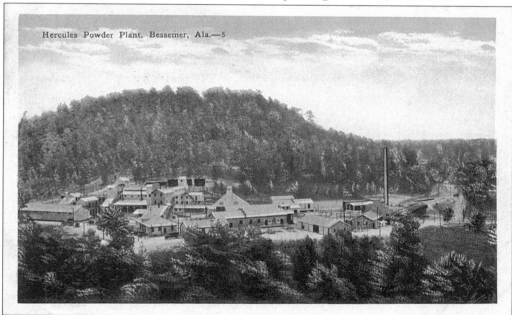

HERCULES POWDER PLANT, BESSEMER. Hercules Powder Plant, located near Bessemer, manufactured dynamite and explosives needed for use in the mines. The plant was spread over a large area to keep the explosive components separated. All workers, and truckers making deliveries, had to check their matches with the guard at the plant entrance. The theme park, "Visionland," is located nearby.

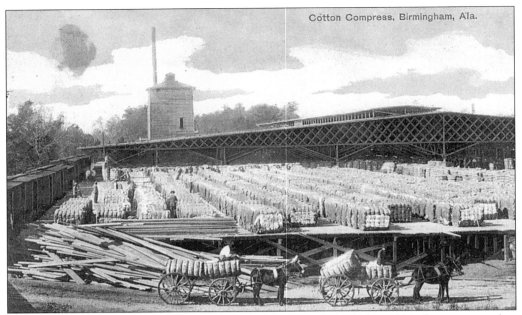

CoTTON COMPRESS, BIRMINGHAM, C. 1911. This postcard, mailed in 1911, shows cotton that has been baled and is waiting to be loaded on the rail cars to the left. Although we have been primarily depicting the industrial development of the Birmingham area, the importance of cotton, as a commodity, must not be overlooked. Unfortunately, view postcards of cotton fields probably just did not excite the traveling photographers and, after all, producing postcards was a business venture.

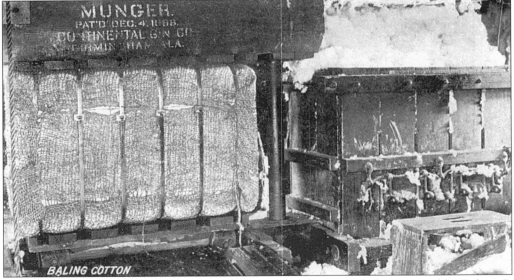

BALING COTTON. This postcard gives a close up view of a cotton baler invented by Robert S. Munger, who established the Continental Gin Company in 1899. Munger purchased the only antebellum home in Birmingham (built by William S. Mudd in 1846) in 1902 and named it Arlington. General Wilson (Wilson's Raiders) occupied the house briefly as his headquarters at the close of the Civil War.

Four

Schools and
Public Buildings

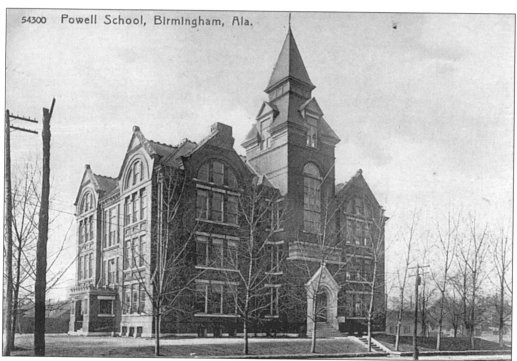

54300 Powell School, Birmingham, Ala.

POWELL SCHOOL, BIRMINGHAM. This c. 1905 postcard shows Powell School, built in 1886, which is located on the southwest corner of Twenty-fourth Street and Sixth Avenue. An earlier wooden structure, built in 1874, was replaced with this building. It was named for Col. James R. Powell, Birmingham's first elected mayor. Mary Calahan was the first principal. A statue of her, created by Guiseppe Moretti, sculptor of *Vulcan*, was placed in Capitol Park, now Linn Park.

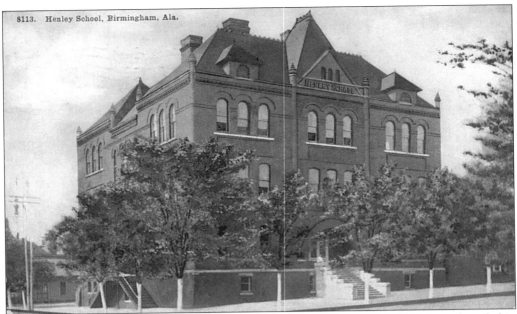

HENLEY SCHOOL, BIRMINGHAM, C. 1911. Henley School, depicted on this postcard mailed in 1911, was named for Robert H. Henley, the first mayor of Birmingham. It was located on the northeast corner of Sixth Avenue and Seventeenth Street. The principal in 1920 was J.M. Burnette.

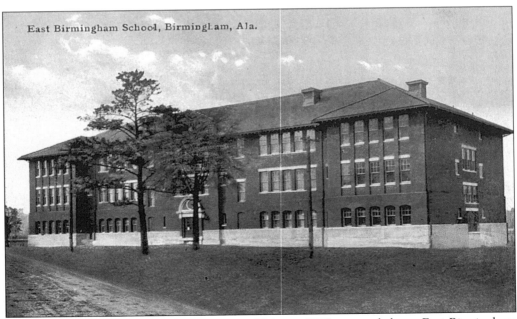

EAST BIRMINGHAM SCHOOL, BIRMINGHAM. This pre-1917 postcard shows East Birmingham School, located at 4606 Twelfth Avenue North. The principal was Alberta Shields, who would later have a school named after her.

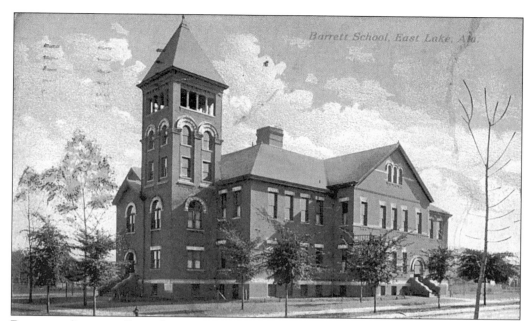

BARRETT SCHOOL, EAST LAKE, C. 1923. This postcard, mailed in 1923, depicts Barrett School, which was built in 1901 and located at 7605 Division Avenue in East Lake. In 1920, the principal was Foster Ansley.

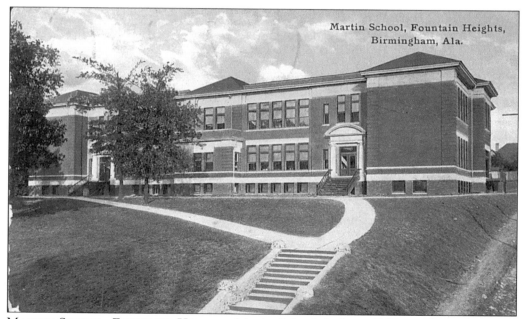

MARTIN SCHOOL, FOUNTAIN HEIGHTS. Martin School, built in 1902, was located at 1201 Fourteenth Street North in Fountain Heights, as shown on this pre-1917 postcard. E.H. Ijams was the principal in 1920.

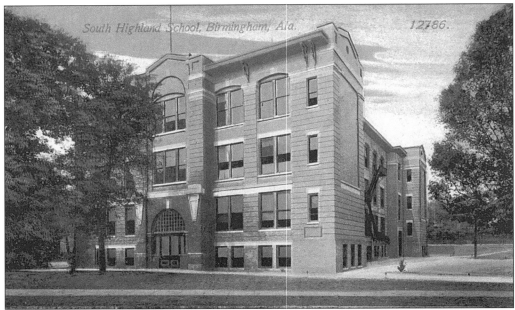

SOUTH HIGHLAND SCHOOL, BIRMINGHAM. South Highland School was located near the Five Points area in South Highlands (see page 35), on Magnolia Street and Twenty-first Street. In 1920, T.C. Young was the principal. It was demolished in the name of progress.

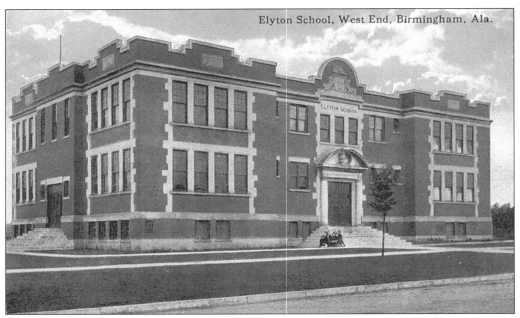

ELYTON SCHOOL, WEST END. This pre-1917 postcard shows Elyton School, built at 100 Tuscaloosa Avenue, which was about the center of the old site of the town of Elyton, the predecessor of Birmingham. In 1920, the principal was W.S. Lane. Note the small group of children on the front steps, posing for this photo.

PAUL HAYNE SCHOOL, BIRMINGHAM, C. 1909. Paul Hayne School, shown on this postcard mailed in 1909, was located on the southeast corner of Fifth Avenue and Twentieth Street South. Built in 1886, it was used at different times as an elementary school, high school, opportunity school, and a vocational school. In the 1920 Birmingham City Directory, it was listed as Junior High School with Clarence J. Going as the acting principal.

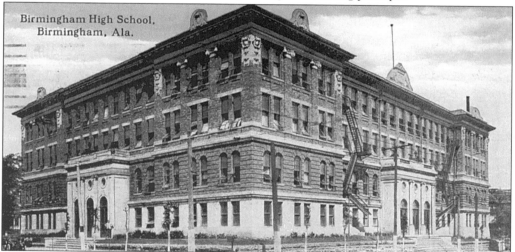

BIRMINGHAM HIGH SCHOOL, C. 1916. Birmingham High School was organized in September 1883 by John Herbert Phillips, first principal and first superintendent of Birmingham schools. It began in a one-room, small brick building at Sixth Avenue and Twenty-fourth Street. By 1885, it had moved to the second floor of the Wright Building on the northwest corner of Third Avenue and Nineteenth Street. In 1890, Birmingham High School was in the old Park Avenue Hotel building (actually a 50-room boardinghouse) on the southwest corner of Park Avenue and Twenty-first Street, across from Capital Park. Construction of a new building, depicted on this postcard, began in 1905 at the corner of Seventh Avenue and Twenty-fourth Street and opened in 1906. The first *Mirror* (student newspaper) was published the following year in May 1907. The name was changed to Central High School in 1911. This building burned on February 11, 1918, and most students were moved to several scattered locations, including the old Medical College Building (see page 89) and Paul Hayne School (see page 69), while construction was begun on a new building (see next page).

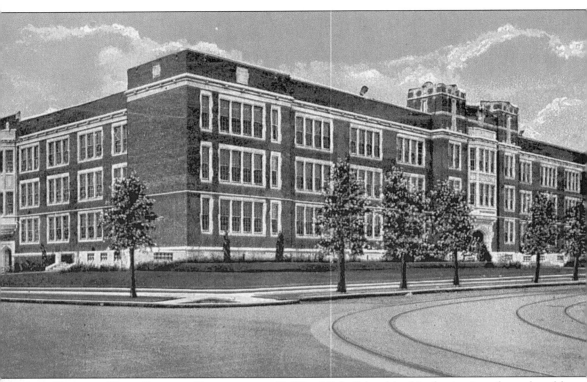

PHILLIPS HIGH SCHOOL, BIRMINGHAM. Phillips High School had its beginnings from the old Birmingham High School (see page 69) and was named for John Herbert Phillips, superintendent of Birmingham schools from 1883 to 1921. This building was constructed to replace the old Central High School, which had burned in 1918. This postcard view shows how Phillips High School looked when the first half of the new school was opened in 1923. A wooden building, not seen, was located behind the school and served as a lunchroom. The enrollment was 2,705. It had been renamed Phillips High School on July 23, 1921, two days after the death of Dr. Phillips. Note the streetcar tracks of the North Birmingham Dummy Line running in front of the school.

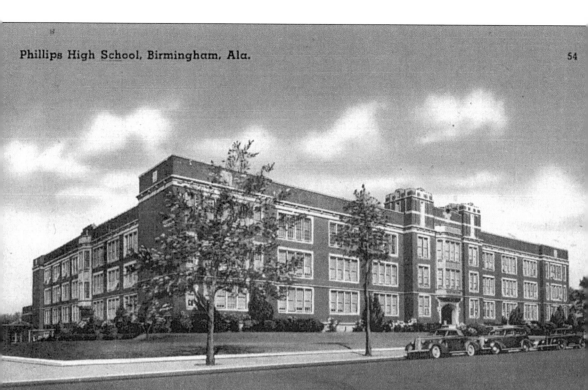

PHILLIPS HIGH SCHOOL. This postcard depicts Phillips High School after the second addition was completed in 1925, during a $3.5 million school building program for all the public schools in Birmingham. The building and equipment was valued at $1,303,666. The principal was Clarence J. Going, and the superintendent was C.B. Glenn, who had assumed the position after the death of Dr. Phillips in 1921 and who would remain until replaced in 1939 by Sellers Stough (my principal). The 1945 *Hand Mirror*, a handbook given to all new students, included a tribute to Dr. John Herbert Phillips that read: "He fashioned his own tools and designed his own models. Builder and organizer, practical in his idealism, he wrought well; and John Herbert Phillips High School is one of his visions made concrete."

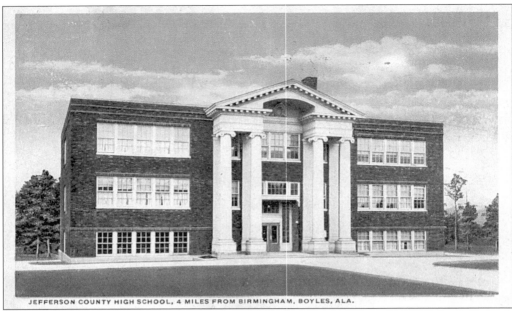

JEFFERSON COUNTY HIGH SCHOOL, 4 MILES FROM BIRMINGHAM, BOYLES, ALA.

JEFFERSON COUNTY HIGH SCHOOL, BOYLES, C. 1921. The Jefferson County High School, established in 1914, was located at Second Avenue and Eighth Street in Boyles. This postcard, mailed in 1921, is actually a view of the original building that burned in 1917. A new school was built on the same site in 1918. The first graduating class (1917) had six students. The principal was T.W. Smith, and the superintendent was E.B. Erwin, for whom the Erwin High School in Center Point was named. The Jefferson County High School would later become Tarrant High School.

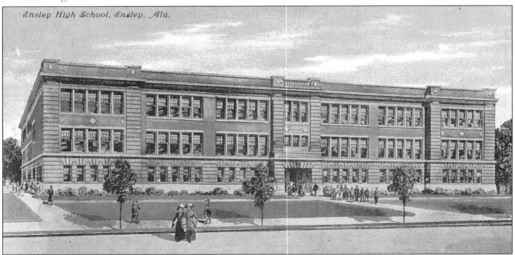

Ensley High School, Ensley, Ala.

ENSLEY HIGH SCHOOL. Ensley High School, built in 1910, is the oldest standing high school building in the Birmingham area. It was built at 2301 Avenue J when Ensley was still a separate town. Ensley High had an opening enrollment of 246 and by 1925 had grown to 1,429. This postcard probably depicts an architect's rendition of the proposed school. With the use of a magnifying glass, you can see that the name of the school on the front of the building reads, "school name here."

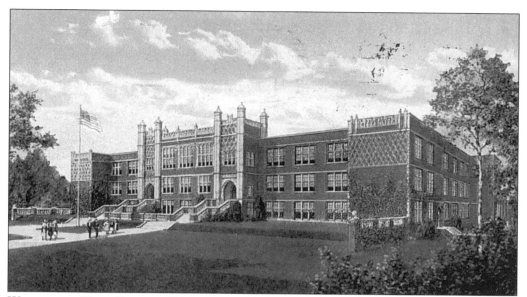

WOODLAWN HIGH SCHOOL, BIRMINGHAM, C. 1923. This postcard was mailed one year after Woodlawn High School opened in 1922 at 5616 First Avenue North. Woodlawn would be enlarged in 1925 at a cost of $456,000, which would increase student capacity from 901 to 1,429. This postcard was mailed to Vancouver, B.C., Canada.

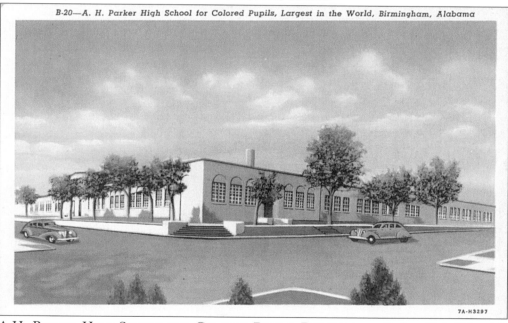

A.H. PARKER HIGH SCHOOL FOR COLORED PUPILS, BIRMINGHAM. Parker High School is depicted on this postcard and proclaimed "the largest high school for Negroes in the world." It started in 1899 with an enrollment of 18 students, and the first class of 15 graduated in 1904. It was called Industrial High School first and later named for the first principal. This building shown opened in September 1924 at the northeast corner of Eighth Avenue and Eleventh Street North.

73

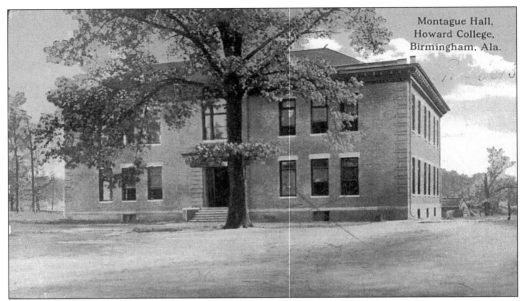

MONTAGUE HALL, HOWARD COLLEGE, EAST LAKE. Howard College, established in Marion, Alabama, in 1842, moved to Birmingham in 1887. It was located on Second Avenue and Seventy-seventh Street South. The East Lake campus was completed in 1892. Shown here on this pre-1917 postcard is Montague Hall.

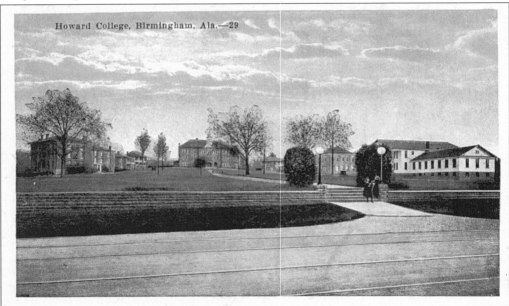

HOWARD COLLEGE. This view shows the Howard College campus looking south from Second Avenue South. The East Lake campus moved to Shades Valley in 1957 on Lakeshore Drive. In 1965, the name was changed to Samford University. Bobby Bowden, current head football coach at Florida State, coached track and football here in the 1950s after graduating, and in the 1960s, he had become the head football coach. His son, Terry, followed in the 1980s also as head coach.

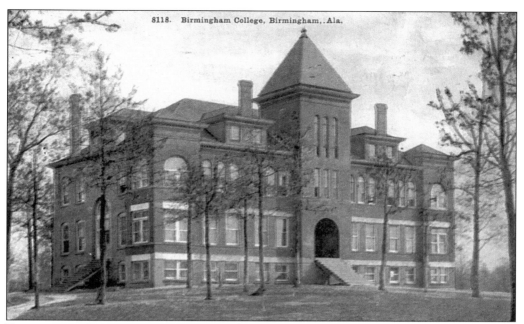

BIRMINGHAM COLLEGE, C. 1912. Birmingham College, seen on this postcard mailed in 1912, was later merged with Southern College to form Birmingham-Southern College.

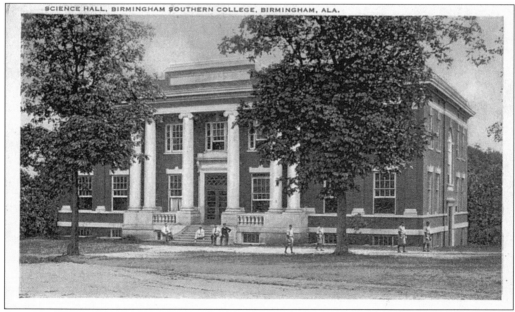

SCIENCE HALL, BIRMINGHAM SOUTHERN COLLEGE, C. 1923. This postcard, mailed in 1923, shows the Science Hall of Birmingham Southern College. Several students are sitting on the steps and appear to be watching four members of the baseball team as they are apparently returning from or going to practice.

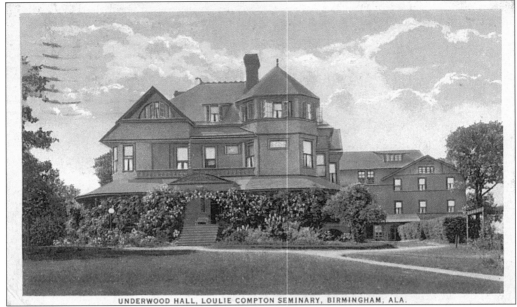

UNDERWOOD HALL, LOULIE COMPTON SEMINARY, BIRMINGHAM, ALA.

UNDERWOOD HALL, LOULIE COMPTON SEMINARY, BIRMINGHAM, C. 1929. Underwood Hall, of the Loulie Compton Seminary, is shown on this postcard mailed in 1929. The Loulie Compton Seminary was originally the Birmingham Seminary (see below) where Miss Loulie Compton was first a teacher, then principal, and then the owner. The postcard is announcing the Alumnae Tea to be held at the Seminary on Saturday afternoon, May 25, from 4 to 6 o'clock. The Class of 1929 were to be the guests of honor.

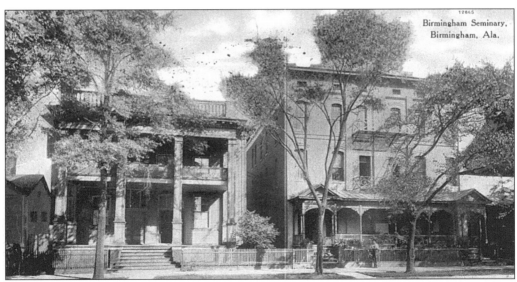

Birmingham Seminary,
Birmingham, Ala.

BIRMINGHAM SEMINARY, C. 1909. This postcard, mailed in 1909, depicts the Birmingham Seminary, a boarding school for women established in 1881, which was located at 1720 Fifth Avenue North. It was also known as the Birmingham Female Seminary, the Birmingham Female Academy in 1883, and Birmingham Female College in 1884. Around 1889, Miss Loulie Compton became a teacher there.

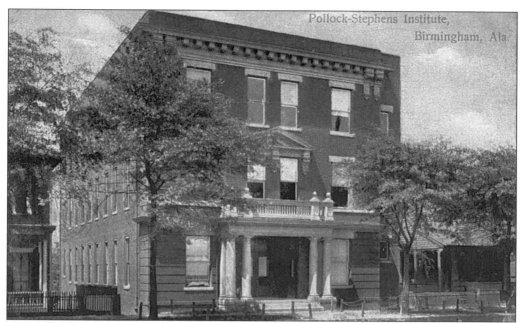

POLLOCK-STEPHENS INSTITUTE, BIRMINGHAM, c. 1909. The Pollock-Stephens Institute, founded in 1890, was located at 718 West Twentieth Street in 1909 when this postcard was mailed. West Twentieth Street was actually one of the two streets that went through Capital Park (now Linn Park) to Eighth Avenue North, one on the west side and one on the east side of the park. West Twentieth Street is the one that now runs behind the present Birmingham City Hall. In 1916, the YWCA purchased this building and used it until 1946, when the City of Birmingham purchased and demolished the building to make way for construction of the new Birmingham City Hall.

MARGARET ALLEN SCHOOL, HIGHLAND AVENUE. This pre-1917 view shows Margaret Allen School, located at 2144 Highland Avenue. It was at this location from 1906 until 1934. The principal was Ms. Willie M. Allen, assisted by her sisters Beff and Ruth.

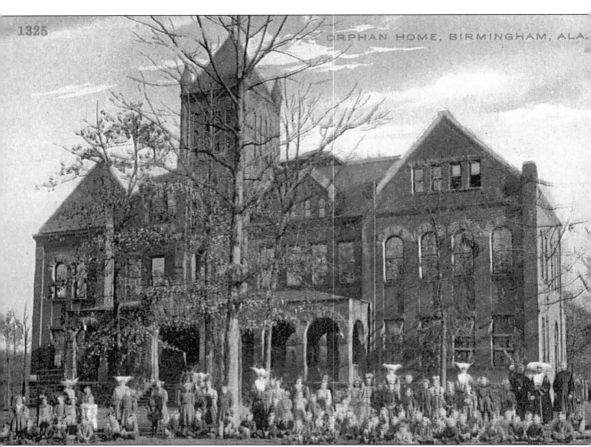

ORPHAN HOME, BIRMINGHAM, ALA.

ORPHAN HOME, BIRMINGHAM. The Orphan Home, shown on this postcard view, was run by Roman Catholic nuns and was originally a women's preparatory school that opened October 7, 1890, as the East Lake Atheneum. Solomon Palmer was president from 1890 until his death in 1896. It was located in East Lake between Eightieth and Eighty-first Streets on Fourth Avenue South. Later it became Saint Thomas on the Hill, an orphanage and school. The headquarters of the Catholic Diocese of Birmingham in Alabama is located on this site now.

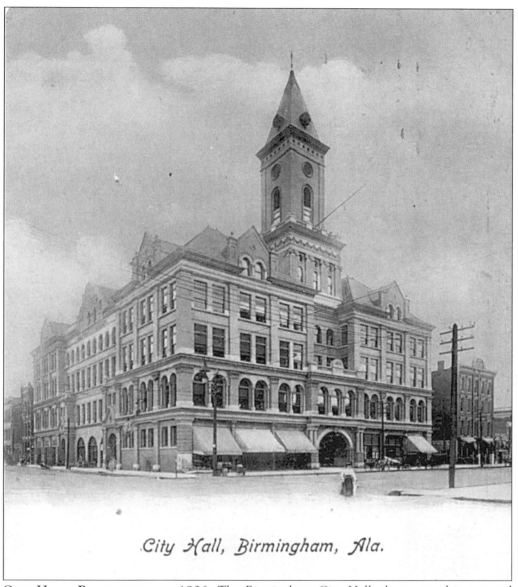

City Hall, Birmingham, Ala.

CITY HALL, BIRMINGHAM, C. 1906. The Birmingham City Hall, shown on this postcard mailed in 1906, was built in 1901 on the southeast corner of Nineteenth Street and Fourth Avenue North. The structure was damaged in a 1925 fire, and the tower and top floor were removed. A new city hall was built and opened in 1950 across from Woodrow Wilson Park (now Linn Park).

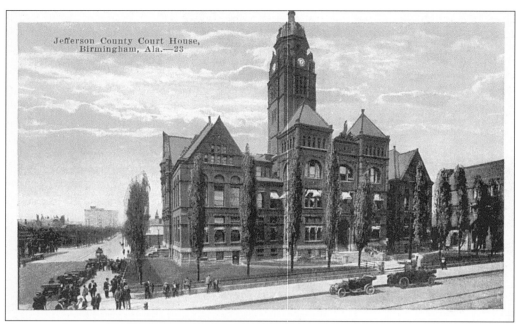

COUNTY COURT HOUSE, BIRMINGHAM. This Jefferson County Courthouse building was erected in 1889 on the northeast corner of Third Avenue and Twenty-first Street North. It replaced an earlier building that was torn down in 1887. Saint Paul's Catholic Church can be seen on the right, and in the background on the left is the Ridgely Apartment building. The current courthouse, opened in 1929, is across from Linn Park (see bottom of next page).

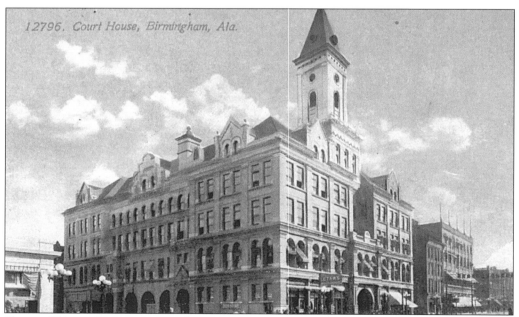

COURT HOUSE, BIRMINGHAM. This postcard, published in Chicago, identifies this building as the courthouse, when it is actually the city hall (compare to page 79). This happened frequently since most postcards were printed and published far away from the local scene.

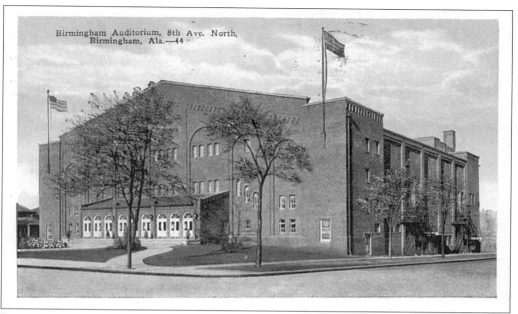

BIRMINGHAM AUDITORIUM, C. 1927. The Birmingham Municipal Auditorium, seen here in this 1927 postcard, was built in the 1920s on the north side of Eighth Avenue North, across from Woodrow Wilson Park. The entrance to the building was remodeled and extended to the street in the 1950s. It was renamed Boutwell Auditorium after former Mayor Albert Boutwell.

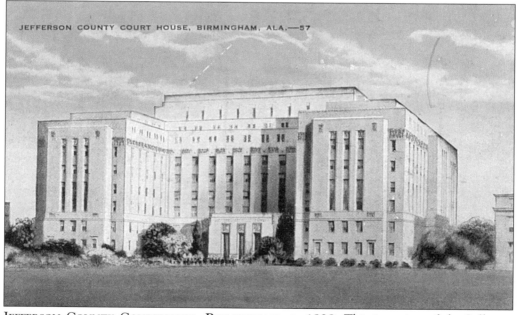

JEFFERSON COUNTY COURTHOUSE, BIRMINGHAM, C. 1929. This is a view of the Jefferson County Courthouse, shortly after opening in 1929. Woodrow Wilson Park is in the foreground, and the Birmingham Public Library, barely visible, is on the right.

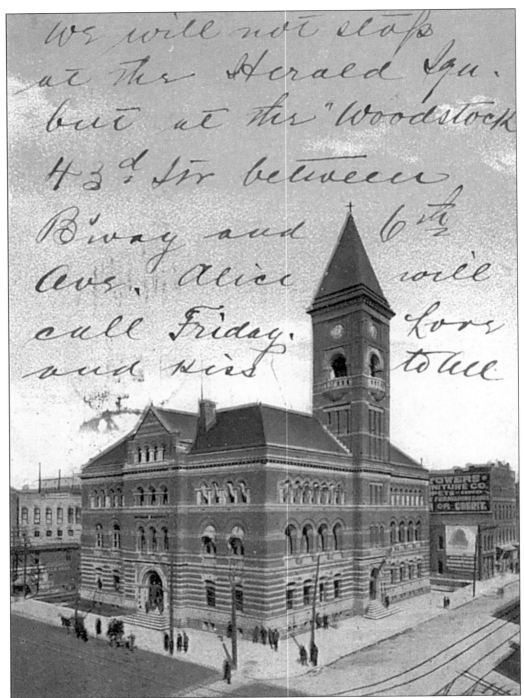

We will not stop
at the Herald Squ.
but at the "Woodstock
43d Str between
B'way and 6½
Avs. Alice will
call Friday. Love
and kiss to all

POST OFFICE, BIRMINGHAM, C. 1907. This 1907 postcard depicts the post office building, built in 1893, at the northeast corner of Second Avenue and Eighteenth Street North. The post office was next located on Fifth Avenue between Eighteenth and Nineteenth Streets and now is on Twenty-fourth Street North between Third and Fourth Avenues.

Five

HOSPITALS AND CHURCHES

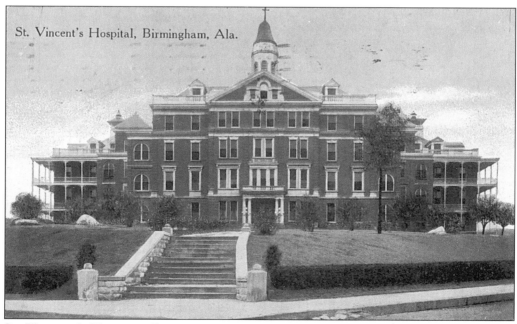

ST. VINCENT'S HOSPITAL, BIRMINGHAM, C. 1916. St. Vincent's Hospital began in 1898 in the DeBardeleben House, between Fifteenth and Sixteenth Streets and Avenues B and C on the Southside. This *c.* 1916 view shows the first permanent building, erected in 1899, after the east wing addition in 1911. During the 1970s and 1980s, all the early structures were replaced, and now the huge St. Vincent's Medical Complex is located on the original site.

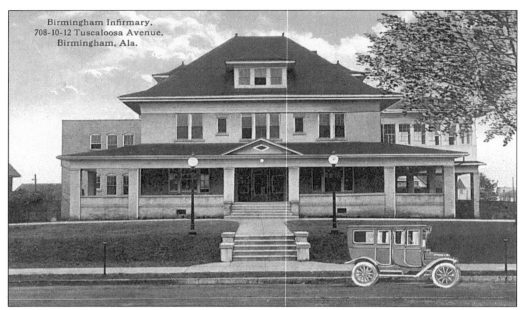

BIRMINGHAM INFIRMARY, BIRMINGHAM. The Birmingham Infirmary, shown here shortly after opening in 1906, was located at 708 Tuscaloosa Avenue. It eventually became a part of the Birmingham Baptist Hospital System and was known as West End Baptist Hospital. None of the original structure exists. It is known today as Baptist Medical Center-Princeton

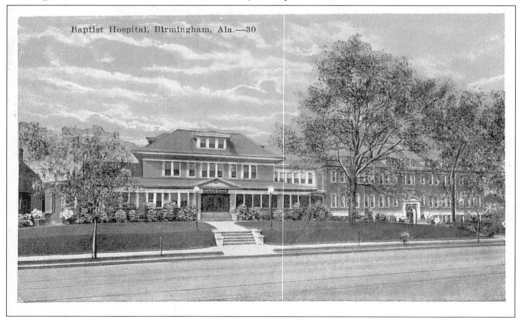

BAPTIST HOSPITAL, BIRMINGHAM, C. 1942. This Baptist Hospital was located on Highland Avenue, just east of Twenty-second Street South. In 1930, the building on the left was the Seale Harris Clinic, founded in 1920, and on the right was the Gorgas Hotel Hospital. The sender of this postcard lived in Ohio and was trading hospital postcards with someone in Wisconsin.

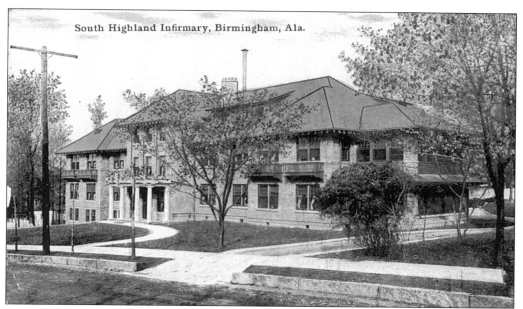

South Highland Infirmary, Birmingham, Ala.

SOUTH HIGHLAND INFIRMARY, BIRMINGHAM. The South Highland Infirmary, shown here shortly after opening in 1910, was at 1127 Twelfth Street South. Today, HealthSouth, the world's largest provider of outpatient healthcare, has its headquarters on this site.

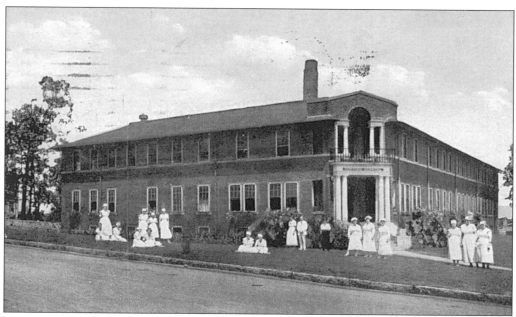

NORWOOD HOSPITAL, BIRMINGHAM, C. 1922. This is a 1922 postcard view of Norwood Hospital, located at 1601 Twenty-fifth Street North. The huge Carraway Methodist Medical Center now occupies this site.

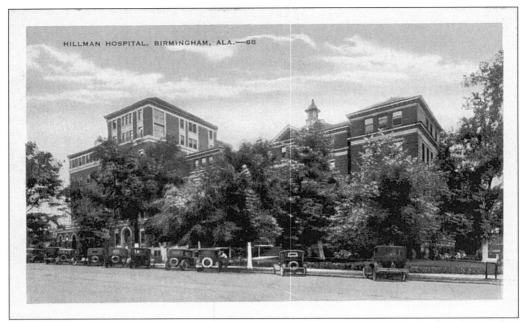

HILLMAN HOSPITAL, BIRMINGHAM. Hillman Hospital, begun in 1890, is considered the oldest hospital in Birmingham. It opened in this building in 1903 at the corner of Sixth Avenue and Twentieth Street South. It was named for Thomas T. Hillman, president of T.C.I. Company, who gave $20,000 in T.C.I. bonds to be held in trust for the hospital. It still stands and is surrounded today by the University of Alabama at Birmingham Medical Center.

TENNESSEE COAL, IRON & RAILROAD HOSPITAL, FAIRFIELD. This postcard, published in 1937, shows the T.C.I. & R.R. Hospital at Fairfield. It was built in 1919 to care for employees and their families. T.C.I. had hired Dr. Lloyd Noland in 1913 as supervisor of health and chief company surgeon. By 1915, Dr. Noland ran eight small hospitals and twelve dispensaries. He established a medical insurance program for employees, who paid 75¢ a month for health care. After the death of Dr. Noland in 1950, the hospital was renamed Lloyd Noland Hospital.

JEFFERSON HOSPITAL, BIRMINGHAM. Jefferson Hospital opened in 1941 and became the teaching hospital for the University of Alabama Medical School in 1945, when it was relocated here from the Tuscaloosa campus. Today, it is part of the huge University of Alabama at Birmingham Medical Center.

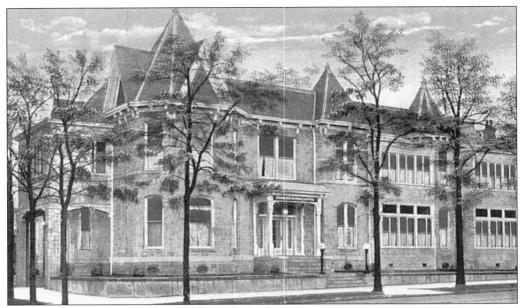

BIRMINGHAM GENERAL HOSPITAL. Birmingham General Hospital, seen in this 1915 postcard view, was located at 2400 Fifth Avenue North between Powell School and the current downtown post office facility. The 1930 Birmingham City Directory had it listed as Alabama General Hospital.

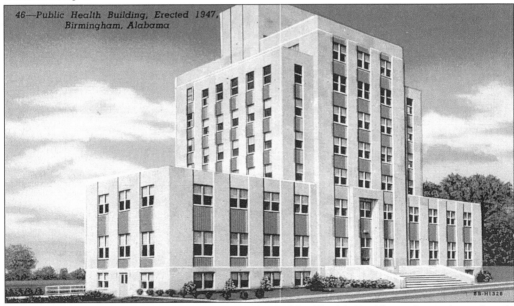

46—*Public Health Building, Erected 1947, Birmingham, Alabama*

PUBLIC HEALTH BUILDING, BIRMINGHAM. The Public Health Building, shown here shortly after construction was completed in 1947, was located on Eighth Avenue between Nineteenth and Twentieth Streets, South. It was the first public health facility built with funds provided by the Hill-Burton Act. Prior to the construction of this building, the Public Health Department had been housed in the Hillman Hospital building (see page 86) since 1944, and before that it was in the city hall building.

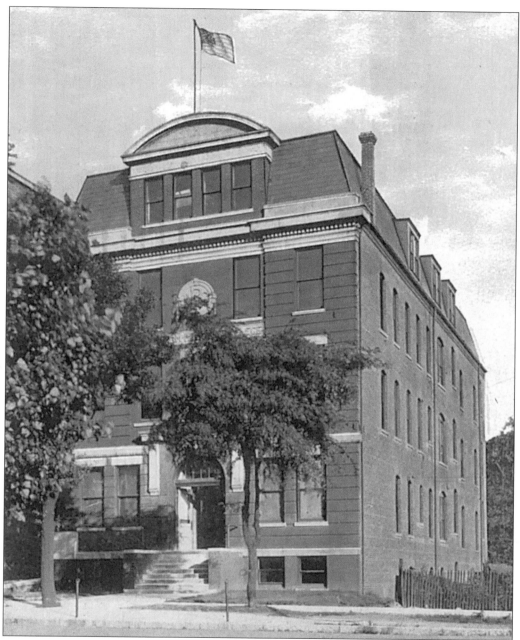

BIRMINGHAM MEDICAL COLLEGE, C. 1913. The Birmingham Medical College, as shown in this 1913 postcard, was established around 1895 in the Lunsford Building located at 209 Twenty-first Street North, along with the Birmingham Dental School. From 1903 until 1913, it was listed at three different addresses on Sixth Avenue South (old Avenue F), between Nineteenth and Twentieth Streets. By around 1916, the Birmingham Medical College had moved into the Hillman Hospital building (see page 86), located at the end of the block on the southwest corner of Sixth Avenue and Twentieth Street. This building housed part of the students of Central/Phillips High School from 1918 to 1923 after their building burned down.

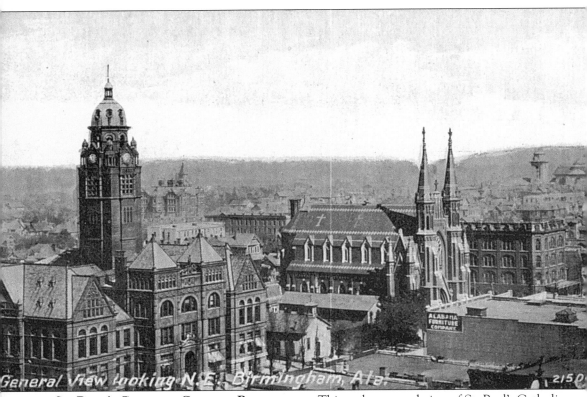

General View looking N.E. Birmingham, Ala. 2150

ST. PAUL'S CATHOLIC CHURCH, BIRMINGHAM. This early postcard view of St. Paul's Catholic Church shows how downtown Birmingham looked c. 1915. This building, constructed in 1893 on land donated by the Elyton Land Company, replaced a previous wood structure located close by. The courthouse (see page 80) is on the left, and the Hotel Mabson is on the right across Twenty-second Street. In the right background is the terminal station, and to the left background is Powell School.

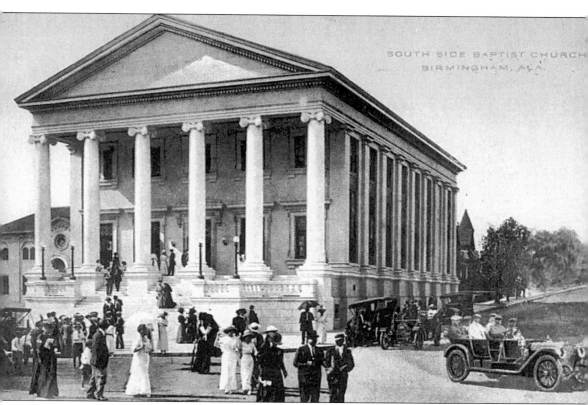

SOUTHSIDE BAPTIST CHURCH, BIRMINGHAM. Southside Baptist Church, established in 1886, is located near Five Points at the intersection of Nineteenth Street and Eleventh Avenue South. The building shown in this postcard view was constructed in 1911.

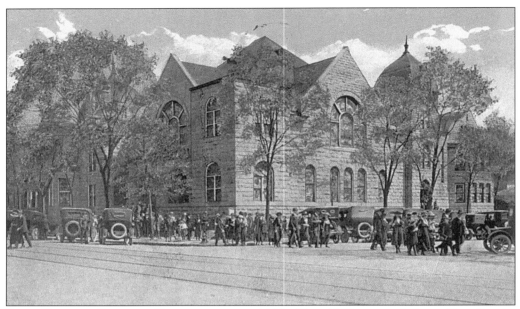

FIRST BAPTIST CHURCH, BIRMINGHAM, C. 1932. This 1932 postcard shows First Baptist Church, located at the corner of Sixth Avenue and Twenty-second Street North. It was established in 1872 on land donated by the Elyton Land Company. The First Baptist Church is now on Lakeshore Drive, near Samford University.

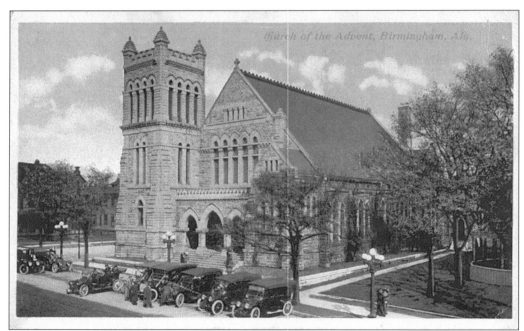

CHURCH OF THE ADVENT, BIRMINGHAM, C. 1915. The Church of the Advent, located at 2019 Sixth Avenue North, is shown on this 1915 postcard. It was built in 1893 to replace an earlier structure, the first church erected in Birmingham, which had been built in 1873. The original land for this church was donated by the Elyton Land Company.

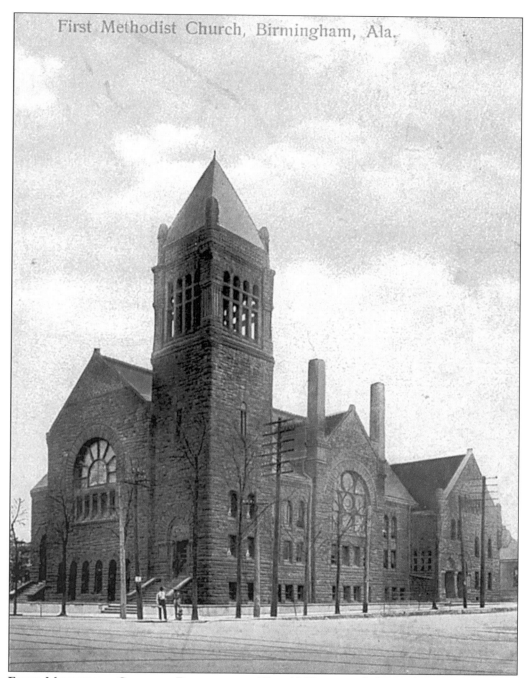

First Methodist Church, Birmingham, Ala.

FIRST METHODIST CHURCH, BIRMINGHAM. This 1908 postcard shows the First Methodist Church, built in 1891, which is located at 518 Nineteenth Street North. The church began in 1872 on the northeast corner of Sixth Avenue and Twenty-first Street North. Next it was on the southwest corner of Fourth Avenue and Nineteenth Street North, and then, in 1891, it moved to the current location. It was originally called the First Methodist Episcopal Church and was built on land donated by the Elyton Land Company.

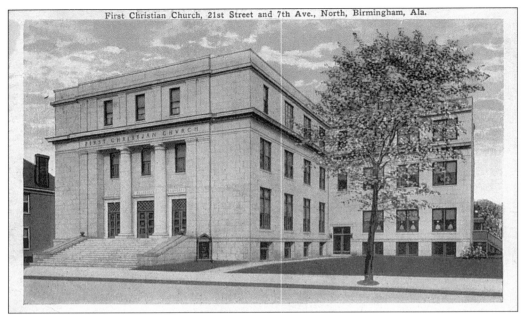

First Christian Church, 21st Street and 7th Ave., North, Birmingham, Ala.

FIRST CHRISTIAN CHURCH, BIRMINGHAM, C. 1931. The First Christian Church, shown here on this 1931 postcard, was located on Seventh Avenue and Twenty-first Street, across from the courthouse. This church was built in 1924 to replace an earlier building, built in 1904, located at Fifth Avenue and Twenty-first Street North. The church moved in 1980, and this structure now houses courthouse records.

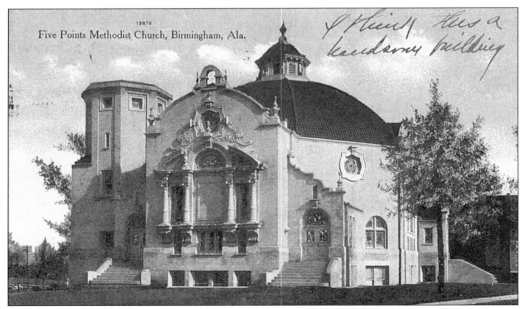

Five Points Methodist Church, Birmingham, Ala.

FIVE POINTS METHODIST CHURCH, BIRMINGHAM. Five Points Methodist Church was built in 1909 at Five Points South. This postcard view was taken shortly after construction but before the bell tower had been completed. An aerial view of the church, with bell tower, can be seen on page 35.

94

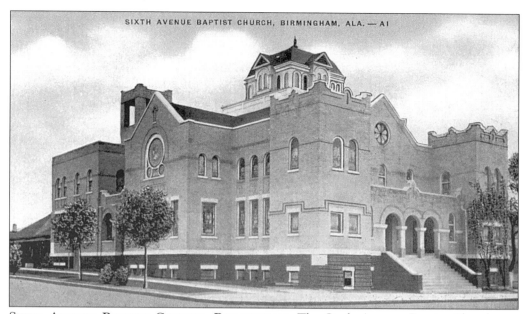

SIXTH AVENUE BAPTIST CHURCH, BIRMINGHAM, ALA. — AI

SIXTH AVENUE BAPTIST CHURCH, BIRMINGHAM. The Sixth Avenue Baptist Church was located at 1529 Sixth Avenue South, where the Cooper Green Hospital now stands. The church was relocated across from Elmwood Cemetery and still carries the name of Sixth Avenue Baptist Church. The back of the postcard proclaims, "One of Birmingham's fine churches. Pastor, the Reverend John W. Goodgame, Jr."

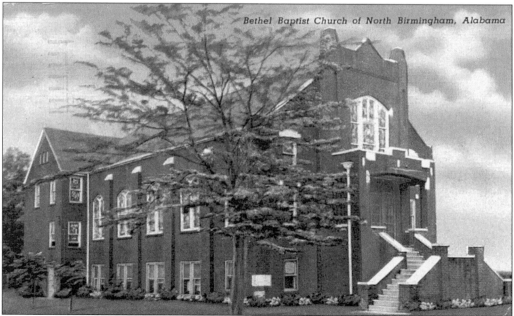

Bethel Baptist Church of North Birmingham, Alabama

BETHEL BAPTIST CHURCH OF NORTH BIRMINGHAM. Built in 1926, the Bethel Baptist Church of North Birmingham was located on Twenty-ninth Avenue and Thirty-third Street North, in the Collegeville area. The back of the postcard indicates that membership was over 500 with 25 active auxiliaries.

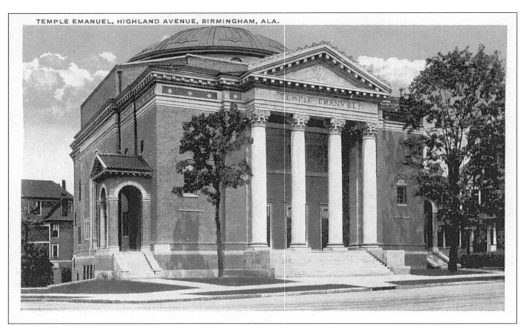

TEMPLE EMANUEL, HIGHLAND AVENUE. With land donated by the Elyton Land Company, Temple Emanuel built their first church at Fifth Avenue and Seventeenth Street North in 1889. The structure shown on this c. 1925 postcard is the second church, built in 1913 at 2100 Highland Avenue, South.

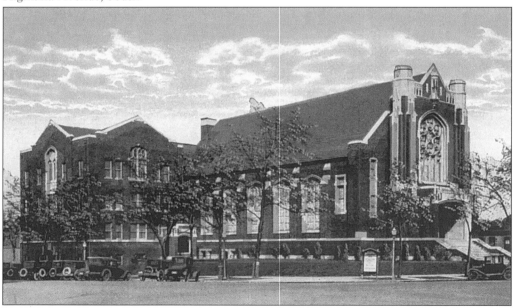

SIXTH AVENUE PRESBYTERIAN CHURCH, BIRMINGHAM. The Sixth Avenue Presbyterian Church, organized in 1871, built this church in 1925 at Sixth Avenue and Eighteenth Street North. The back of this c. 1925 postcard states that this building has an educational building 63 by 163 feet, spacious kitchen, dining room, parlors, gym, and an auditorium with a capacity of 1,200.

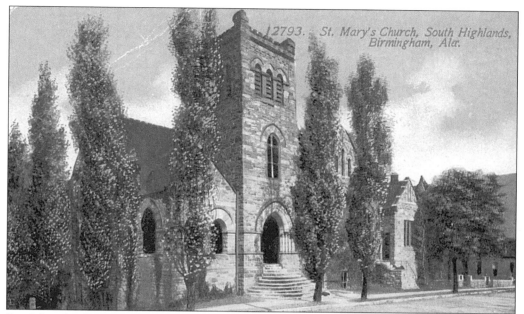

ST. MARY'S CHURCH, SOUTH HIGHLANDS. St. Mary's Church was built in 1892 at 1910 Twelfth Avenue South on Highland Avenue. It replaced an earlier church, built in 1888, located on the northeast corner of Magnolia Avenue and Twentieth Street South that had been destroyed by fire. It is now called St. Mary's on the Highlands.

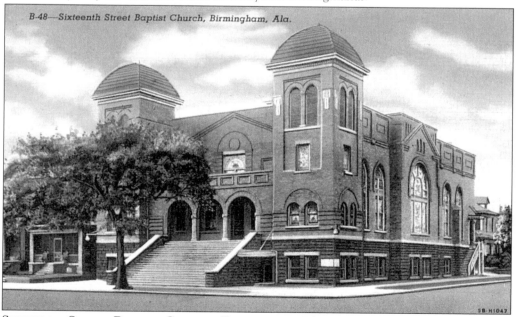

SIXTEENTH STREET BAPTIST CHURCH, BIRMINGHAM. The Sixteenth Street Baptist Church, built in 1911, is located at 1530 Sixth Avenue North. It was originally called "The First Colored Baptist Church of Birmingham" and was located at several other sites nearby. Wallace A. Rayfield, an early black architect, designed it. It is well known for being the site of a 1963 church bombing and the focal point of the Civil Rights movement in Birmingham.

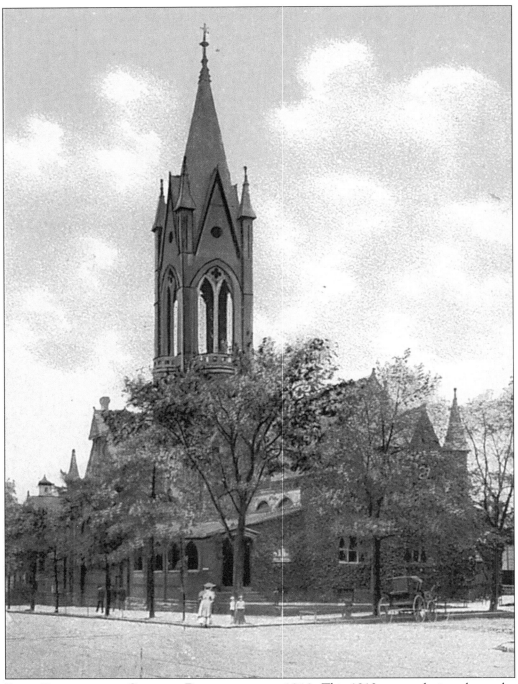

FIRST PRESBYTERIAN CHURCH, BIRMINGHAM, C. 1910. This 1910 postcard view shows the First Presbyterian Church structure that was built in 1888. When the Elyton Land Company announced plans to donate land for churches, First Presbyterian was the first to select a site and build. The old building was dismantled and hauled from Elyton in wagons to be reassembled around 1872.

Six

HOTELS

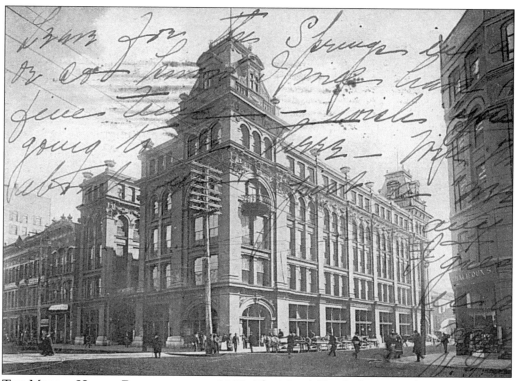

THE MORRIS HOTEL, BIRMINGHAM, C. 1907. The Morris Hotel, shown on this 1907 postcard, was originally built in 1888 for business offices. It was located on the corner of First Avenue and Nineteenth Street North. The building across on the right was the Chalifoux Studio Building. In 1930, it had 14 music teachers listed as instructors. The old Morris Hotel was demolished in 1959.

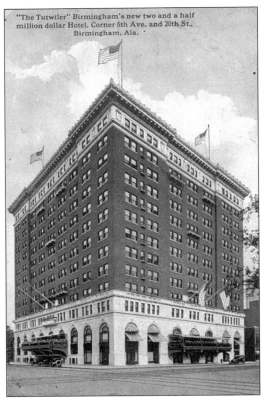

"The Tutwiler" Birmingham's new two and a half million dollar Hotel, Corner 5th Ave. and 20th St., Birmingham, Ala.

THE TUTWILER HOTEL, BIRMINGHAM, C. 1915. The Tutwiler Hotel was built in 1914 on the southeast corner of Fifth Avenue and Twentieth Street. This postcard, mailed to a distant cousin of mine in 1915, was given to me by her daughter. I sadly watched as the hotel was demolished in 1974 to make way for the new First Alabama Bank building.

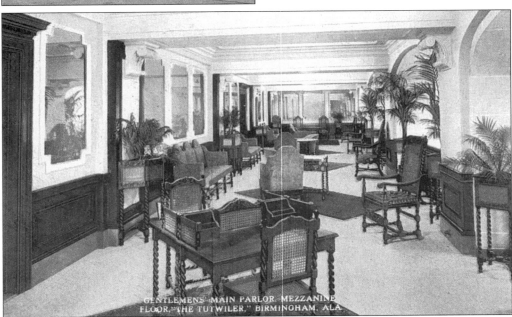

GENTLEMENS' MAIN PARLOR, MEZZANINE FLOOR, "THE TUTWILER," BIRMINGHAM, ALA.

GENTLEMEN'S MAIN PARLOR, MEZZANINE FLOOR, TUTWILER HOTEL, C. 1915. This 1915 postcard depicts the Gentlemen's Main Parlor of the Tutwiler Hotel. With 450 rooms, the Tutwiler was the largest hotel in Birmingham for many years.

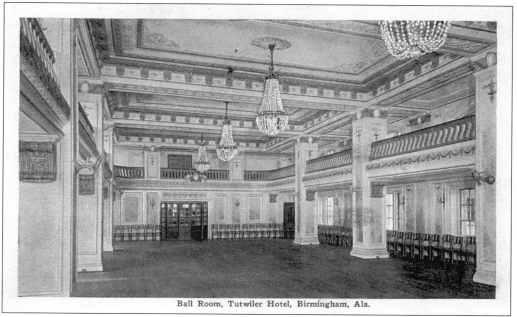

Ball Room, Tutwiler Hotel, Birmingham, Ala.

BALLROOM, TUTWILER HOTEL, C. 1930. The ballroom of the Tutwiler was very impressive, as this 1930 postcard shows, with its high ceilings and large chandeliers. This was the scene of parties and dances over the 60 years it existed, and thousands of folks, myself included, have pleasant memories of this hotel.

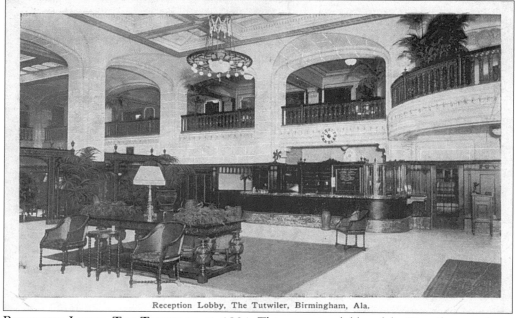

Reception Lobby, The Tutwiler, Birmingham, Ala.

RECEPTION LOBBY, THE TUTWILER, C. 1921. This reception lobby of the Tutwiler must have been a splendid sight when it opened on June 15, 1914. It is shown on this 1920 postcard.

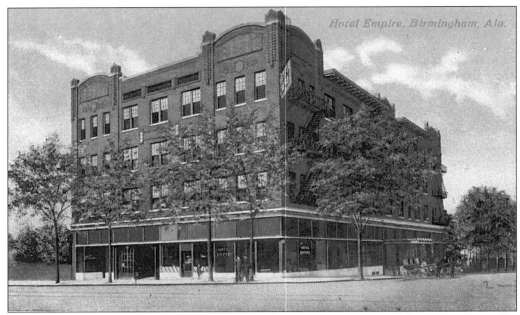

HOTEL EMPIRE, BIRMINGHAM. The Empire Hotel, as this *c.* 1915 postcard shows, was located at 2130 Fourth Avenue North. Note the horse and buggy parked on Twenty-second Street on the right of the building. The First Presbyterian Church (see page 98) was located on the corner to the left and the *Birmingham News* was on the right across the street.

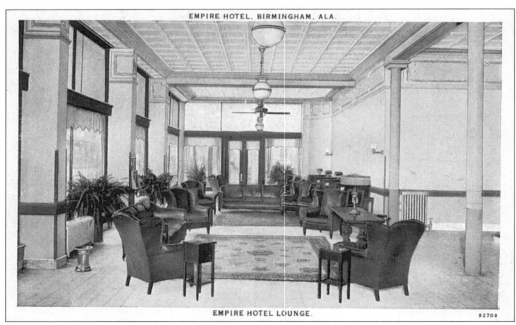

EMPIRE HOTEL LOUNGE. The lounge of the Empire Hotel is shown in this *c.* 1915 postcard. The advertisement on the back proclaims it to be a hotel of quiet dignity, having the atmosphere and appointment of a well-conditioned home.

HOTEL RODEN, BIRMINGHAM.
Construction was started on the Hotel
Roden in 1913 at Fifth Avenue and
Eighteenth Street North; however, in 1914,
it was discontinued, and the hotel was never
finished. This is typical of the use of
postcards to advertise a new business with
an artist's rendition of a building.

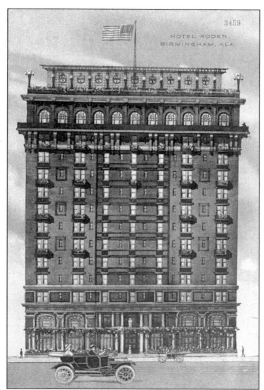

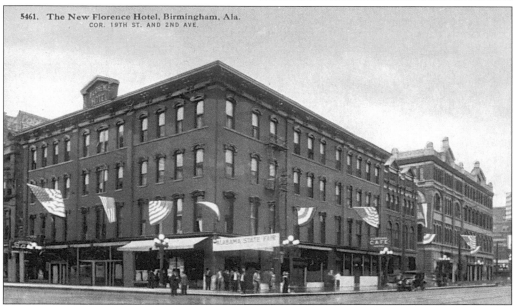

THE NEW FLORENCE HOTEL, BIRMINGHAM. This *c.* 1915 postcard depicts the New Florence
Hotel, which was located on the corner of Second Avenue and Nineteenth Street North.
Loveman, Joseph & Loeb can be seen to the right. Flags and banners are out on the street, and
the banner hanging from the building to the lamppost is announcing the Alabama State Fair.

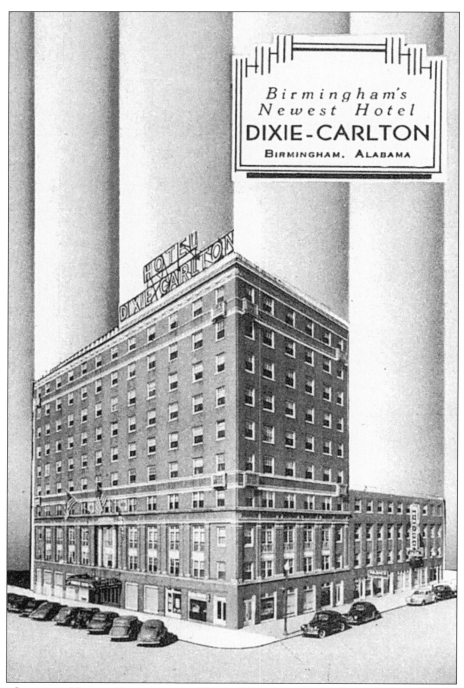

DIXIE-CARLTON HOTEL, BIRMINGHAM. This building became the Dixie-Carlton Hotel in the 1930s. It was built in 1926 for the Birmingham Athletic Club (see page 31). In 1946, it was purchased by the YWCA for $437,500 and opened in 1948. It is still the YWCA and continues operation today. This postcard announces there is a new air-conditioned coffee shop. You can dine and dance in the Mirror Room, and the W.S.G.N. studios are located there.

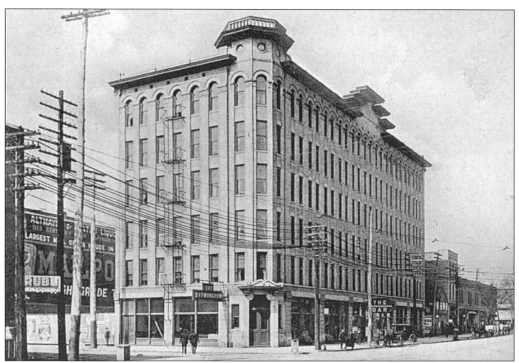

THE BIRMINGHAM HOTEL. This *c.* 1906 postcard shows the Birmingham Hotel, located at 1732 Second Avenue North. The post office building is across the street to the right (see page 82), and the Jefferson Theatre (see page 28) is down the street to the left.

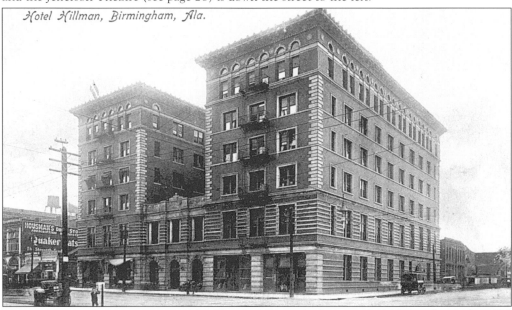

HOTEL HILLMAN, BIRMINGHAM. The Hotel Hillman, built around 1902, was located at 322 Nineteenth Street North. The City Hall (see page 79) is across the street. The Hillman Hotel was demolished in 1967 in the name of progress and replaced by a parking lot.

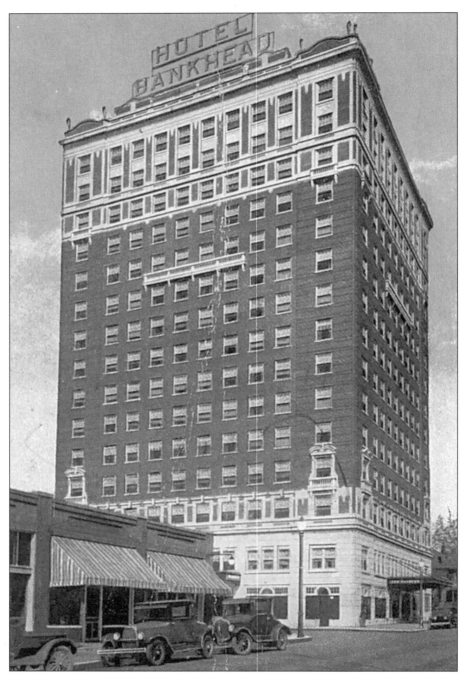

HOTEL BANKHEAD, BIRMINGHAM, C. 1929. The Hotel Bankhead, built in 1926, stood on the northeast corner of Fifth Avenue and Twenty-third Street as this 1929 postcard shows. The Henry Mansfield Café is across Twenty-third Street, with all the cars out front. In the late 1950s, when Bear Bryant came back to Alabama to coach football, he headquartered the Crimson Tide at the Bankhead. The building is still standing and is presently used as housing for the elderly and handicapped.

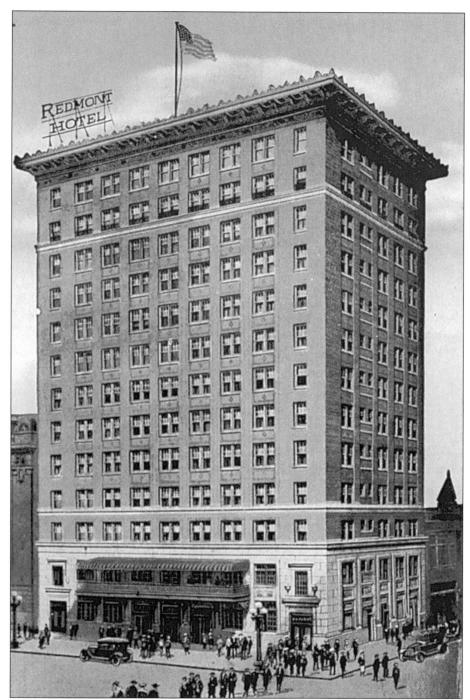

HOTEL REDMONT, BIRMINGHAM. This c. 1915 postcard shows the Redmont Hotel as it looked then on the northeast corner of Fifth Avenue and Twenty-first Street North. The back of the postcard calls the Redmont "Birmingham's Newest Hotel," with 225 rooms, 225 baths, and circulating water.

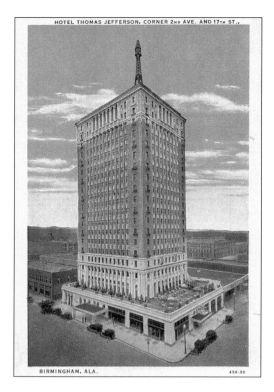

HOTEL THOMAS JEFFERSON, BIRMINGHAM.
The Thomas Jefferson Hotel was built in the 1920s on the southwest corner of Second Avenue and Seventeenth Street North. This *c.* 1915 postcard indicates on the back that the Thomas Jefferson is Alabama's tallest, at 20 stories plus a tower on top, and Birmingham's newest. It also reminds travelers to "Look for the Red Beacon" on top of the tower. The building is still standing but is not used as a hotel.

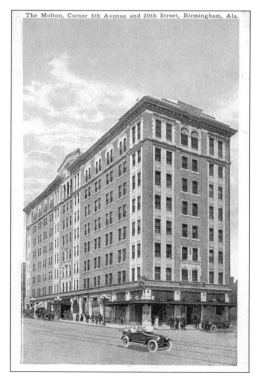

THE MOLTON HOTEL, BIRMINGHAM. The Molton Hotel, built in 1913, was located on the northeast corner of Fifth Avenue and Twentieth Street, across from the Tutwiler. The Molton, along with the Tutwiler, Redmont, and Bankhead, were built on Fifth Avenue, since it was a direct link to the Terminal Station (see page 18) where hundreds of passengers arrived daily.

Seven

PARKS

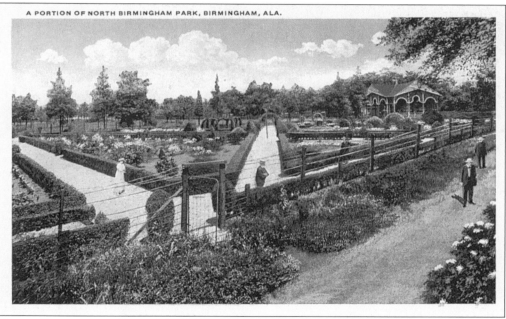

A PORTION OF NORTH BIRMINGHAM PARK, BIRMINGHAM, ALA.

NORTH BIRMINGHAM PARK. North Birmingham Park was at the end of the streetcar line that served the town of North Birmingham. It had been built around some springs and was a popular picnic spot. The Country Club of Birmingham was founded there in 1898 with 77 members. They first built a clubhouse and tennis courts, and then, on April 1, 1899, they opened a nine-hole golf course in a former pasture. The country club moved to Lakeview Park (see page 112) after Dimmick Pipe Company built on the site of the golf course. An exclusive gun club moved there in 1899 and claimed as a member John Phillip Sousa. Later a baseball field, dancing pavilion, tennis courts, and lake pavilion were added. A swimming pool was built about 1930.

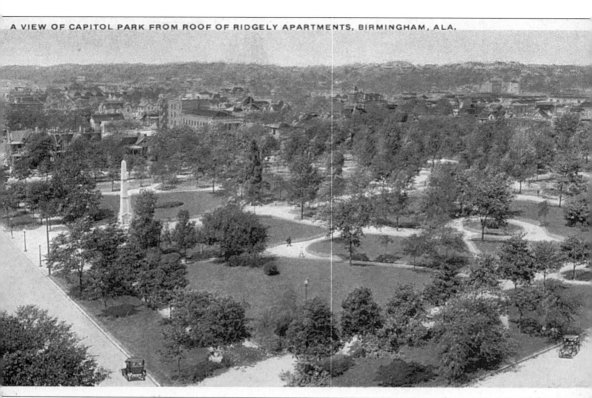

CAPITOL PARK FROM THE ROOF OF RIDGELY APARTMENTS, BIRMINGHAM. This c. 1915 postcard shows a view of Capitol Park, later called Woodrow Wilson Park and now Linn Park, looking west from the newly built Ridgely Apartments on Twenty-first Street. The tall building at the edge of the park is the YWCA building, the current site of the Birmingham City Hall. The bottom edge of the park is where the current Linn-Henley Research Library is located. The tall Confederate Monument at the left, with cornerstone placed on April 26, 1894 (see next page), faces where Twentieth Street now dead-ends at the park. The early founders had visions of making Birmingham the state capitol and developed this park for that purpose, hence the name, Capitol Park.

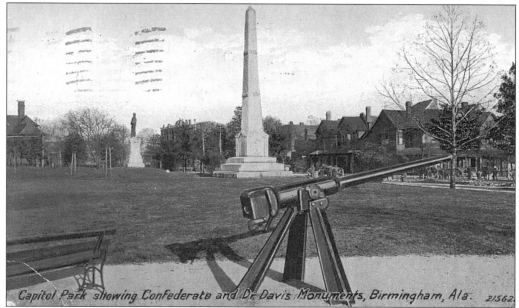

Capitol Park showing Confederate and Dr. Davis Monuments, Birmingham, Ala. 21562

CAPITOL PARK SHOWING CONFEDERATE AND DR. DAVIS MONUMENTS, C. 1912. This 1912 view of Capitol Park shows that the surrounding area was still primarily residential with large homes at the edge of the park. The monument to Dr. W.E.B. Davis, an early Birmingham physician, was erected in 1904. It was cast in bronze by Guiseppe Moretti, who also did *Vulcan* and the Mary Calahan statue. The message on the back of this postcard, mailed April 13, 1912, reads "Down here for a few days on a business trip. Expect to be in Phila about 4/27 and will try to find you and your Pittsburgh friend."

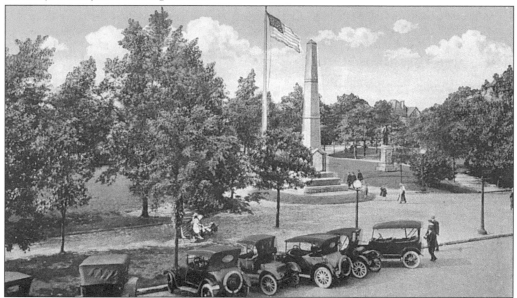

ANOTHER VIEW OF CAPITOL PARK. This *c.* 1920 view of Capitol Park appears to include a Sunday outing with everyone dressed in their finest. The Confederate Monument and the statue of Dr. Davis are visible to the right.

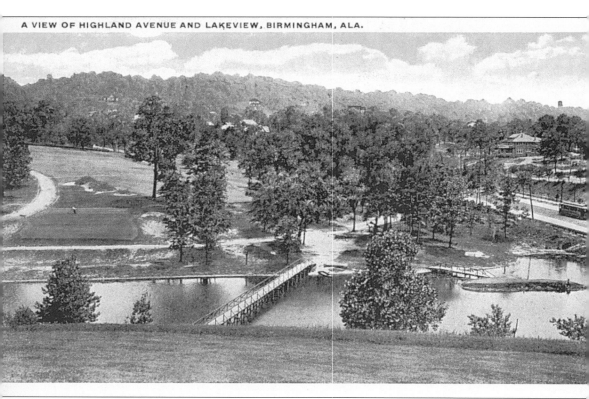

HIGHLAND AVENUE AND LAKEVIEW, BIRMINGHAM. The Elyton Land Company built Lakeview Park in the 1880s at the end of Highland Avenue. In 1904, the Birmingham Country Club moved here from North Birmingham and built a golf course. This c. 1915 postcard view is looking from the top of the hill above the lake. To the left, across the lake, is a golfer who is putting on hole number one, named Lakeside. The holes were named in the Scottish tradition. Over to the right is a streetcar traveling on Highland Avenue. The first Alabama-Auburn football game was played down the street on February 22, 1893, where Highland Avenue intersects with Clairmont Avenue and Thirty-second Street.

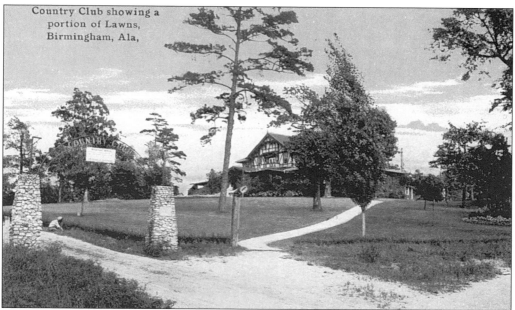

Country Club showing a portion of Lawns, Birmingham, Ala,

COUNTRY CLUB, BIRMINGHAM. This pre-1917 postcard shows the Country Club of Birmingham that opened at Lakeview Park in grand style on April 7, 1904. The club opened at six in the morning and remained open until midnight, seven days a week. No game could be played for money in the clubhouse or on the grounds.

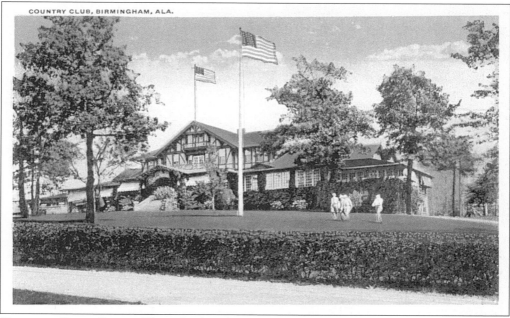

COUNTRY CLUB, BIRMINGHAM, ALA.

COUNTRY CLUB, CLOSER VIEW. In this closer view of the clubhouse, it appears that several of the men on the front lawn have golf bags. The Birmingham Country Club moved from this site in 1928 to Shades Mountain. Afterwards, the golf course was operated by the City of Birmingham as the Charlie Boswell Golf Course. This structure burned in 1972.

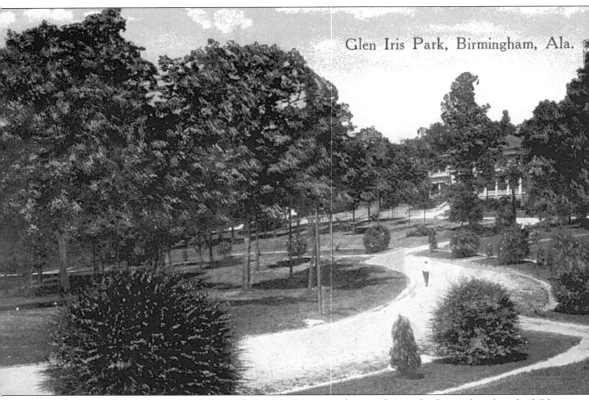

Glen Iris Park, Birmingham, Ala.

GLEN IRIS PARK, BIRMINGHAM. This *c.* 1910 postcard view shows the horseshoe bend of Glen Iris Circle in Glen Iris Park. Robert Jemison Sr. developed this residential neighborhood and lived at 16 Glen Iris Circle. W.P.G. Harding, president of First National Bank of Birmingham, was another original resident of Glen Iris. He was appointed to the first Federal Reserve Board by President Woodrow Wilson in 1914 and elevated to chairman in 1916.

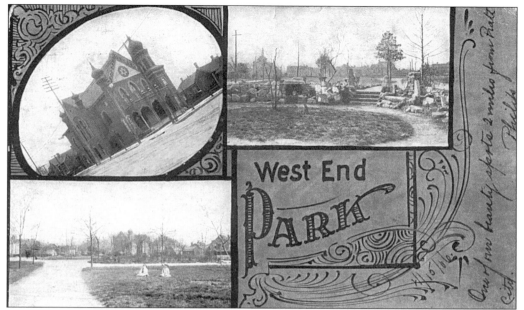

WEST END PARK, C. 1906. West End Park, as shown on this *c.* 1906 postcard, is one of two parks set aside when the Elyton Land Company laid out the city of Birmingham in 1871. The other was East Park, which eventually became the baseball field for Phillips High School. West End Park was later named Kelly Ingram Park in memory of Osmond Kelly Ingram of Pratt City, the first U.S. sailor killed in World War I. It is now in the heart of the Civil Rights district with the Sixteenth Street Baptist Church (see page 97) and the Birmingham Civil Rights Institute located at the north and west sides of the park.

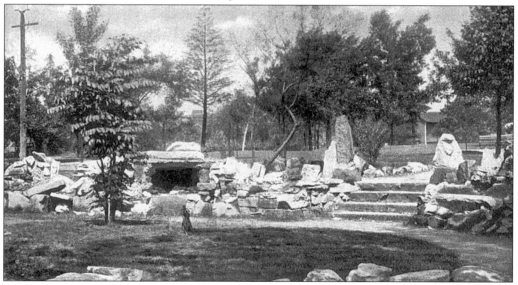

WEST END PARK, CLOSER VIEW, C. 1908. This *c.* 1908 postcard shows a closer view of West End Park. The message on the back is an update on someone's health. It indicates the person is feeling fine but weighs only 91 pounds and is trying to get fat before returning to Haleyville (Alabama).

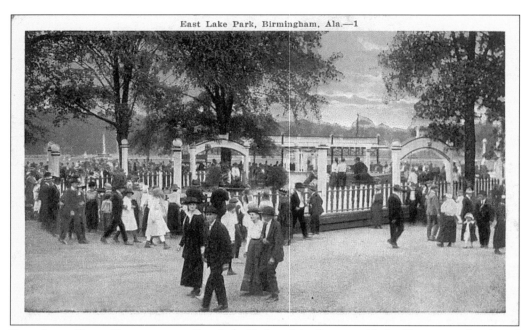

EAST LAKE PARK, BIRMINGHAM. East Lake Park, originally named Lake Como, was developed by the East Lake Land Company in 1887 to attract people to their new residential development. It proved to be very popular, as can be seen in this *c.* 1920 postcard view.

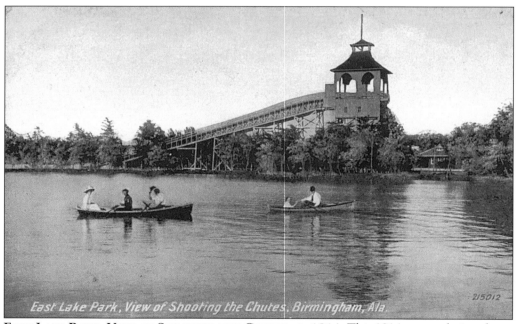

East Lake Park, View of Shooting the Chutes, Birmingham, Ala.

215012

EAST LAKE PARK, VIEW OF SHOOTING THE CHUTES, C. 1914. This 1914 postcard view shows the 34-acre lake with the roller coaster in the background. The sender states they "had a fine time here last Sunday." In addition to the lake and roller coaster, there was also a hotel, dance pavilion, zoo, boat rides, swimming pool, fishing, and many other attractions.

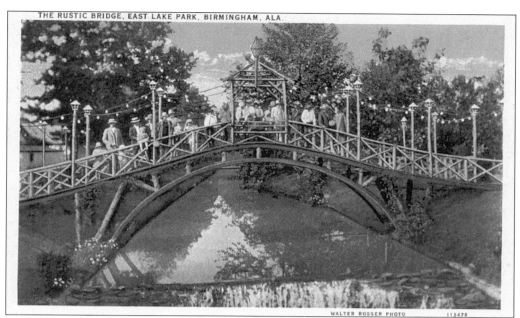

THE RUSTIC BRIDGE, EAST LAKE PARK, BIRMINGHAM, ALA.

WALTER ROSSER PHOTO 113478

THE RUSTIC BRIDGE, EAST LAKE PARK, BIRMINGHAM. This rustic wood bridge spanned the creek as you entered East Lake Park from the First Avenue side. Although the hotel, roller coaster, and old casino are gone, the creek and lake still remain. Today, if you enter the park from the First Avenue side, you still have to cross over this creek.

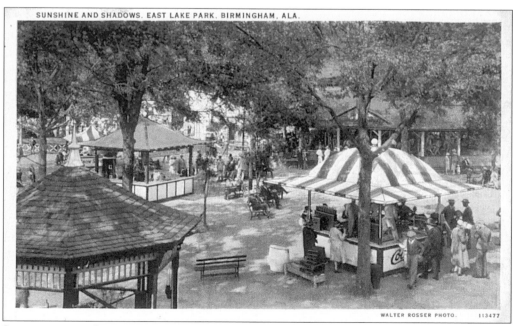

SUNSHINE AND SHADOWS. EAST LAKE PARK. BIRMINGHAM. ALA.

WALTER ROSSER PHOTO. 113477

SUNSHINE AND SHADOWS, EAST LAKE PARK. This c. 1920 postcard proclaims on the back that this is "Dixie's Most Popular Playground." Note the partially hidden Coca-Cola sign at lower right.

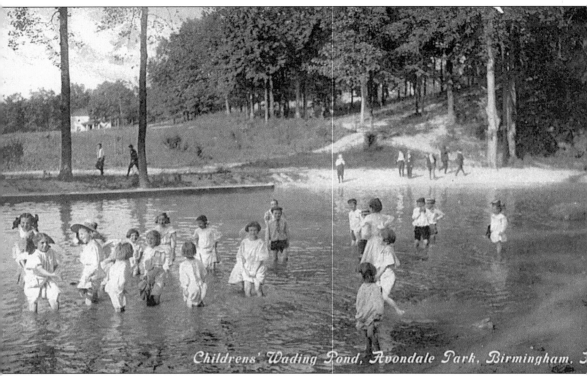

Childrens' Wading Pond, Avondale Park, Birmingham.

CHILDREN'S WADING POND, AVONDALE PARK, C. 1912. The Avondale Land Company, founded by Ben F. Roden before 1888, built Avondale Park on a 40-acre site. The park was named for the River Avon in Shakespeare's village. Avondale Park was a very popular place at the turn of the 20th century and was accessible by a one-mule streetcar that ran from Birmingham to the middle of the town of Avondale. This 1912 postcard, mailed from Cory (original name for Fairfield), depicts the favorite part of the park for the children—the wading pond.

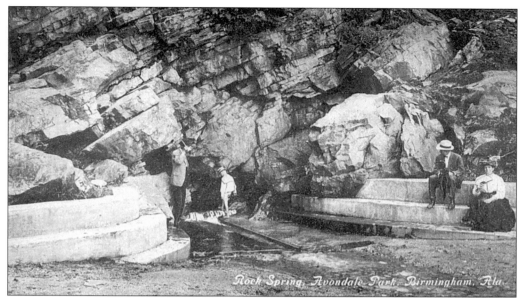

ROCK SPRING, AVONDALE PARK. The "Rock Spring" at Avondale Park, actually an underwater stream that flowed from the mouth of the cave, is shown in this *c.* 1910 postcard. This had been a clear, clean water supply for early residents and farms when Birmingham was founded in 1871. Water was hauled into Birmingham at a cost of 10¢ a barrel. The Truss Home Guard fired upon General Wilson and his Union Army as they watered their horses here during the Civil War.

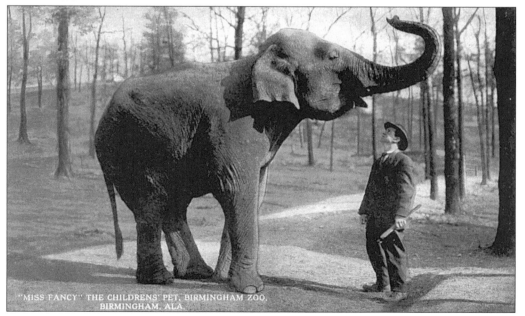

"MISS FANCY," THE CHILDREN'S PET, BIRMINGHAM ZOO, C. 1914. Most sources report that a zoo was added to Avondale Park in 1917; however, this postcard, mailed December 27, 1914, clearly shows the Birmingham Zoo had been added at least three years earlier. "Miss Fancy" the elephant was truly a children's favorite.

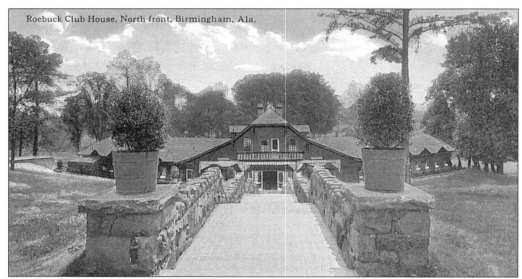

ROEBUCK CLUB HOUSE, BIRMINGHAM. This *c.* 1915 postcard shows the entrance to the clubhouse at Roebuck Springs Country Club. The club, started in 1911, also had one of the early golf courses in the Birmingham area. Many fine homes were built in Roebuck Springs (see page 46). All that remains of this park today is the Roebuck Golf Course, owned by the City of Birmingham, where the links are still crowded with golfers seven days a week.

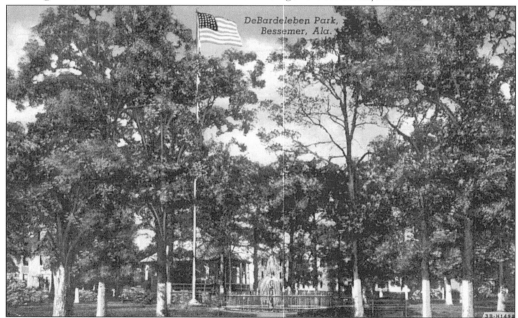

DEBARDELEBEN PARK, BESSEMER, C. 1948. This postcard view shows the DeBardeleben Park in Bessemer, named for Henry DeBardeleben, who was instrumental in the founding of Bessemer in 1887. DeBardeleben, in order to speed up the growth of the city, purchased buildings from the World Exposition of 1884 in New Orleans and shipped them by train to Bessemer to be reassembled. The park was originally named Berney Park for the founders of the Berney Bank in Bessemer.

Eight
MISCELLANEOUS

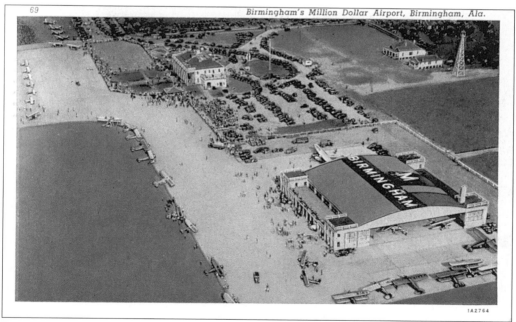

BIRMINGHAM'S MILLION DOLLAR AIRPORT, C. 1939. The Birmingham Airport was dedicated on June 1, 1931. It covered 315 acres and had room for 300 to 500 planes, as proclaimed by this postcard. When Charles Lindbergh landed at Roberts Field in 1927, after his solo flight across the Atlantic Ocean earlier in the year, he urged the city fathers to build an airport. Within four years, the Birmingham Airport was open for business. The white structure at the top of the postcard was the terminal building.

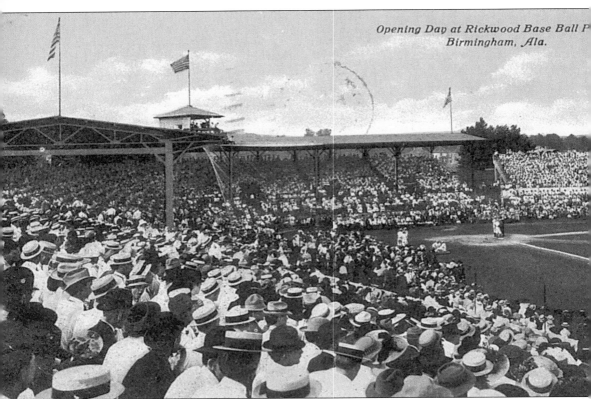

OPENING DAY AT RICKWOOD BASEBALL PARK, BIRMINGHAM, 1910. This 1910 postcard shows the opening day crowd for the new Rickwood Baseball Park on August 18, 1910. Rick Woodward, who owned the team and liked to suit up in uniform, threw the first pitch, not ceremonial, but as the starting pitcher. His first pitch was a ball, and he immediately left the game and returned to the owner's box. The Birmingham Barons (shortened from Coal Barons) defeated the Montgomery Climbers, 3-2, by bunting four times in a row. The place was packed with most folks riding the streetcar from downtown Birmingham, where businesses closed and as the *Birmingham News* reported, "downtown was empty." Rickwood has seen all the greats like Babe Ruth, Ty Cobb, Dizzy Dean, and, of course, the Birmingham Black Barons with Willie Mays, Piper Davis, and many more. Rickwood is the oldest baseball park in the world and is still in use today.

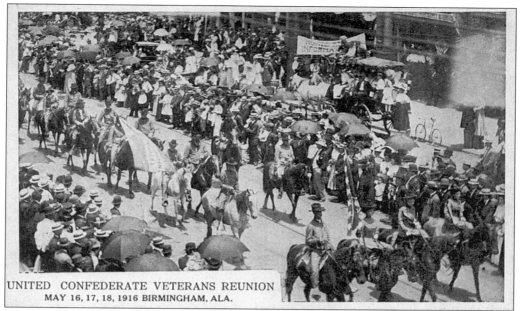

UNITED CONFEDERATE VETERANS REUNION
MAY 16, 17, 18, 1916 BIRMINGHAM, ALA.

UNITED CONFEDERATE VETERANS REUNION, BIRMINGHAM, 1916. The United Confederate Veterans Reunion was held in Birmingham May 16–18, 1916. The headquarters for the meetings was the Tutwiler Hotel (see page 100), with hundreds of participants camped at the Alabama State Fairgrounds. Six thousand veterans attended, including my great-great-grandfather, John Leonard Weeks, with another 10,000 family members. An estimated 100,000 watched the parade. The Confederate Reunions took place from 1890 to 1932, with Birmingham as the host city in 1894, 1908, 1916, and 1926.

THE FRISCO INTO BIRMINGHAM. This *c.* 1910 postcard shows the Frisco train steaming into Birmingham. The Frisco was one of the seven railroads serving the city in 1907. The others were the Southern, Seaboard, Central of Georgia, Alabama Great Southern, Illinois Central, and L&N Railroads. The L&N Railroad used their depot on Morris Avenue, and the others used the terminal station on Twenty-sixth Street. The Frisco, with tracks built through the Warrior Coal Fields as early as 1886, had a rail yard east of Highway 78 in East Thomas, now the site of the Finley Avenue Produce Market.

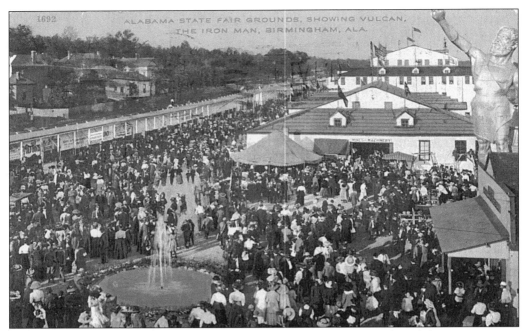

ALABAMA STATE FAIR GROUNDS, BIRMINGHAM, C. 1911. This is the Alabama State Fair, probably in 1910, with the Mines-Machinery Exhibition Hall and lots of people. *Vulcan* (the Iron Man) can be seen on the right, where he had been placed after being exhibited at the St. Louis Exhibition in 1904. The sender of this postcard is telling a friend to come down to the fair in October (1911).

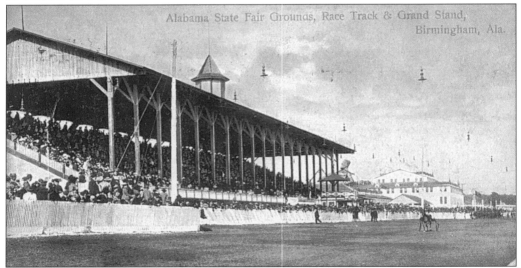

FAIR GROUNDS RACE TRACK AND GRAND STAND, C. 1908. This *c.* 1908 view of the Alabama State Fairgrounds depicts the racetrack and grandstand. This same racetrack is where NASCAR greats Bobby Allison, Donnie Allison, Neil Bonnett, Red Farmer, and Davy Allison learned their trade. Auto racing (horses and dogs race at another location) continues today, and the grandstand looks pretty much the same, except for *Vulcan*, who was placed on top of Red Mountain in 1936.

FIRE AT BIRMINGHAM RAILROAD, LIGHT & POWER COMPANY OFFICE, 1914. This real photo postcard is an example of how postcards could record a spectacular event, such as this fire on May 8, 1914, when the Birmingham Railroad, Light & Power Company building burned. Two people were killed when they leaped from the burning building. The structure was rebuilt at the same site on the northeast corner of First Avenue and Twenty-first Street North, now called the Landmark Center.

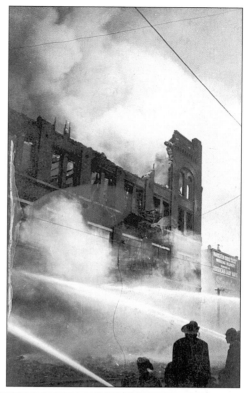

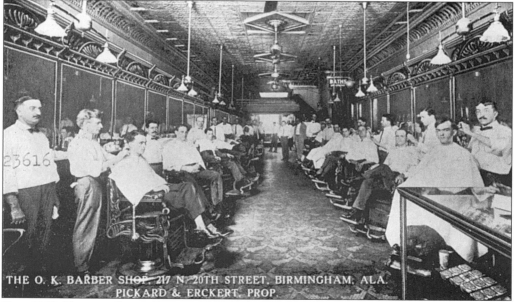

THE O.K. BARBER SHOP, BIRMINGHAM. This postcard is actually a reprint of the original printed by Curt Teich Company *c.* 1907. The O.K. Barber Shop was located at 217 Twentieth Street North, and was quite large. Note the sign in the back that indicates a bath is located upstairs.

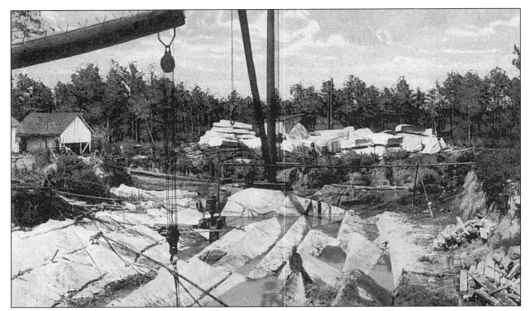

WHITE MARBLE QUARRY, BIRMINGHAM. Marble was another of the natural resources that abounded near the Birmingham area, as indicated by this c. 1920 postcard. This unidentified quarry was most likely located southeast of Birmingham.

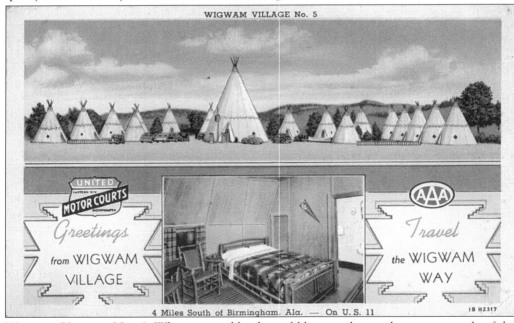

WIGWAM VILLAGE NO. 5. What postcard book would be complete without an example of the Wigwam Villages that sprang up as automobiles displaced trains as the primary mode of transportation. This Wigwam Village No. 5 was located on U.S. Highway 11, west of Birmingham on the Bessemer Super Highway. This postcard announces that the Indian Wigwams are insulated, have complete baths, solid hickory furniture, hot and cold running water, heat in the winter, and fans in the summer. What more could you ask for?

BIBLIOGRAPHY

Atkins, Leah Rawls. *The Valley and the Hills: An Illustrated History of Birmingham & Jefferson County*. Tarzana, California: Windsor Publications, Inc., 1981.

Birmingham Centennial Corporation. *Portrait of Birmingham, Alabama*. Birmingham, Alabama: Oxmoor Press, 1971.

Brown, Virginia Pounds. *Grand Old Days of Birmingham Golf*. Birmingham, Alabama: Beechwood Books, 1984.

Burkhardt, Ann McCorquodale. *House Detective-A Guide to Researching Birmingham Buildings*. Birmingham, Alabama: Birmingham Publishing Company for Birmingham Historical Society, 1988.

Burkhardt, Ann McCorquodale. "Town Within a City: The Five Points South Neighborhood 1880–1930," ed., Alice Meriwether Bowsher. *The Journal of the Birmingham Historical Society*, Vol. 7, Nos. 3-4 (November 1982).

Caldwell, H.M. *History of the Elyton Land Company and Birmingham, Ala*. Birmingham, Alabama: Birmingham Publishing Company for Southern University Press, 1972.

Carver, Sally S. *The American Postcard Guide to Tuck*. Brookline, Massachusetts: Carves Cards, 1982.

City Directory. Birmingham: R.L. Polk and Company, 1899–1930.

Fiftieth Anniversary-Official Souvenir Program. Birmingham, Alabama: Birmingham Semi Centennial Committee, 1921.

Flynt, J. Wayne. *Mine, Mill and Microchip: A Chronicle of Alabama Enterprise*. Northridge, California: Windsor Publications, 1987.

Foscue, Virginia O. *Place Names in Alabama*. Tuscaloosa, Alabama: The University of Alabama Press, 1989.

Henley, John C., Jr. *This is Birmingham: The Story of the Founding and Growth of an American City*. Birmingham, Alabama: Birmingham Publishing Company, 1969.

Hudson, Alvin W. and Harold E. Cox. *Street Railways of Birmingham*. Forty Fort, Pennsylvania: Harold E. Cox, 1976.

Jefferson County and Birmingham, Alabama. Birmingham, Alabama: Farm Movement Department of the Birmingham, Alabama Chamber of Commerce, 1911.

Lewis, Pierce and Marjorie Longenecker White. *Birmingham View: Through the Years in Photographs*. Birmingham, Alabama: Birmingham Historical Society, 1996.

McMillan, Malcolm C. *Yesterday's Birmingham*. Miami, Florida: E.A. Seeman Publishing, 1975.

Nicholson, Susan Brown. *The Encyclopedia of Antique Postcards*. Radnor, Pennsylvania: Wallace-Homestead, a division of Chilton Book Company, 1994.

Norton, Bertha Bendall. *Birmingham's First Magic Century: Were You There?* Birmingham, Alabama: Lakeshore Press, 1970.

Ragan, Larry. *True Tales of Birmingham*. Birmingham, Alabama: Birmingham Historical Society, 1992.

Satterfield, Carolyn Green. *Historic Sites of Jefferson County, Alabama*. Birmingham, Alabama: Jefferson County Historical Commission, 1976 (revised 1985).

Smith, Jack H. *Postcard Companion: The Collector's Reference*. Radnor, Pennsylvania: Wallace Homestead Book Company, 1989.

Staff, Frank. *The Picture Postcard and Its Origins*. New York: Frederick A. Praeger, 1966.

Sulzby, James F. *Historic Alabama Hotels and Resorts*. Tuscaloosa, Alabama: The University of Alabama Press, 1960.

The Birmingham News. *Our First 100 Years*. Birmingham, Alabama: The *Birmingham News*, 1988.

The Pioneer Club. *Early Days in Birmingham*. Birmingham, Alabama: Birmingham Publishing Company, 1937, (Reprinted 1969).

White, Majorie Longenecker, ed. *Downtown Birmingham: Architectural and Historical Walking tour Guide*. Birmingham, Alabama: Birmingham Historical Society, 1977.

White, Majorie Longenecker. *The Birmingham District: An Industrial History and Guide*. Birmingham, Alabama: Birmingham Historical Society, 1981.

Whitt, Timothy. *Bases Loaded With History-The Story of Rickwood Field: America's Oldest Baseball Park*. Birmingham, Alabama: The R. Boozer Press, 1995.

Willoughby, Martin. *A History of Postcards*. London, England: Bracken Books, 1994.

Wofford, Tom. *The Saint Vincent's Story: A Century of Caring*. Birmingham, Alabama: St. Vincent's Foundation, 1997.

Wood, Jane. *The Collector's Guide to Post Cards*. Gas City, Indiana: L. & W. Promotions, 1984.